y

The Technique of
Icon Painting

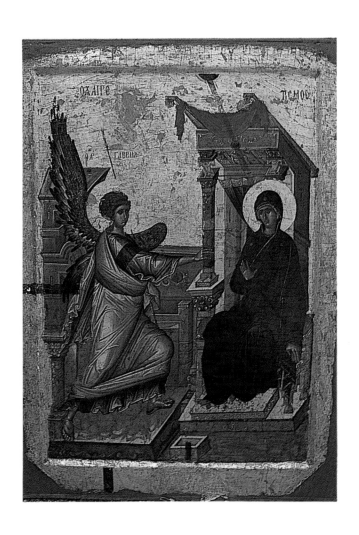

Front cover: *The Annunciation based on an early fourteenth century Byzantine icon in the Ohrid Icon Gallery, Yugoslavia. 72.5 × 54cm (28½ × 21¼in). Original (page 1) 94.6 × 80.3cm (37¼ × 31⅝in).*

Page 1: *The Annunciation, early fourteenth century icon in Ohrid Icon Gallery, Yugoslavia. 94.6 × 80.3cm (37¼ × 31⅝in).*

Page 3: *Virgin of the Passion, or Our Lady of Perpetual Succour 55 × 40.6cm (21¾ × 16in). Roman Catholic Church of our Lady and St Joseph, Dalston, London. Based on a Cretan-Sienese icon now in the Redemptorist Monastery, Rome.*

The Technique of
Icon Painting

Guillem Ramos-Poquí

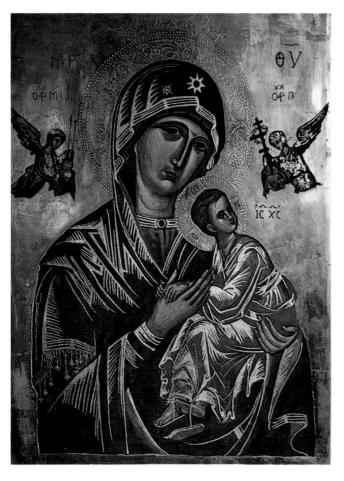

MOREHOUSE PUBLISHING

Harrisburg, PA Wilton, CT

First published in Great Britain 1990

Search Press Ltd and Burns & Oates Ltd

First American edition published by Morehouse Publishing
Editorial Office 78, Danbury Road Wilton, CT 06897
Coporate Office P.O. Box 1321, Harrisburg, PA 17105

Line drawings, geometric drawings and the following icons are by
Guillem Ramos-Poquí: *The Annunciation*, front cover, and detail
page 61; *The Virgin of the Passion*, pages 3 and 68; *The Virgin
Hodigitria*, page 35; *Christ Pantocrator*, page 42; *Crucifixion*, page
67; *The Transfiguration*, page 71, (now in the Benedictine
Monastery of Christ in the Desert, Abiguiu, NM, USA).

The publishers acknowledge with thanks the permissions received
to reproduce some of the transparencies in this book: the
Iconostasis on page 8 and the *Crucifixion* on page 67, by courtesy of
the Byzantine Museum, Athens; *St Peter* on page 16 and *Triumph
of the Orthodoxy* on pages 72 and 73 (National Icon Collection nos.
7 and 18) by courtesy of the Trustees of the British Museum,
London; the detail of Duccio's *Transfiguration* on page 53,
reproduced by courtesy of the Trustees, The National Gallery,
London; *The Ascension* on page 65, by courtesy of The Temple
Gallery, London.

The publishers and author would also like to give a special thanks
to the Yugoslavian authorities and the Icon Gallery, Ohrid,
Yugoslavia, for allowing the author direct access to photograph the
following icons: *The Annunciation* on page 1 and a detail on page
54; *The Virgin Hodigitria* (complete and detail) on page 29; *The
Virgin Hodigitria* pages 36 and 37.

The publishers also gratefully acknowledge the permissions
received to reproduce the following copyright material:

Extracts on pages 76 and 77 taken from the *Jerusalem Bible*,
published and copyright 1966, 1967 and 1968 by Darton, Longman
and Todd Ltd and Doubleday & Co Inc, and are used by permission
of the publishers.

The prayer for the blessing of icons on page 69 is from *An Orthodox
Prayer Book* edited by N. M. Vaporis, published by Holy Cross
Orthodox Press, Brooklyn, Mass., 1977.

The Roman Catholic prayers on pages 68 and 69 for the blessing of
icons are from *The Book of Blessings – The Roman Ritual*
published by Icel (International Commission on English in the
Liturgy) Inc., Washington DC. 1987.

ISBN 0-8192-15554

Author's Acknowledgements

I am indebted to:
Elizabeth, who helped to write this book.

The late Ola Okuniewska-Wolpe, painter and former pupil of
Johannes Itten at the Bauhaus, who introduced me to sacred art.

Dr Isaac Fanous Youssef, Official Iconographer of the Orthodox
Coptic Church, who introduced me to the technique of icon
painting.

I would also like to thank Lady Christina Hoare (Christian Art
Collection, Kent) for the loan of *The Annunciation* which appears
on the front cover and on page 61; His Eminence Cardinal Basil
Hume for the loan of *The Crucifixion* which appears on page 67;
and the Roman Catholic Church of Our Lady and St Joseph,
Kingsland, Dalston, London, for allowing me to photograph the
icon of *The Virgin of the Passion* on pages 3 and 69.

I am also grateful to:
Vassa Nicolau for her assistance in painting the icon of *The
Annunciation* on the front cover; Lara Boucoyannis for checking
the historical detail in the 'Introduction'; Protoklis-Pieris Nicola
for the help with the Greek texts; Claudio Astrologo, Adrian and
Ilda Lees, Drumond and Katherine Cuthbert (restorers) for advice
on varnishing and gilding; Rosalind Dace, Editor of Burns and
Oates Ltd./Search Press Ltd. for her enthusiasm, and all my
students for their encouragement.

Sincere thanks are also due to my students from Westminster
Institute, London, who have their works reproduced in this book:
Vassa Nicolau, *The Archangel Gabriel* page 43 (top right), *The
Virgin of Katafigi and St John the Evangelist* page 52, *St Symeon
Theodochos* page 52 and assistance with *The Annunciation* page 61
and cover; Patricia Hamilton, *The Archangel Michael* page 17;
Jacqueline Klemes, *Virgin Eleousa* pages 45 and 51, *The Virgin* page
49, *Christ in Glory* page 56; Ella D'Souza, *Evangelist St Matthew*
page 23; Baboo Roberts, *St John the Baptist* page 43; Jean Dowling,
The Archangel Gabriel page 43 (bottom right); Bonnez Le Touzel,
St George and the Dragon page 57; Jane Kennedy, *Transfiguration*
page 57; Jan Reeves, *The Baptism of Christ* page 58 and drawing
page 74; Beryl Howson, *The Raising of Lazarus* page 59.

Composition by Genesis Typesetting, Laser Quay, Rochester, Kent

Printed by Times Publishing Group

Contents

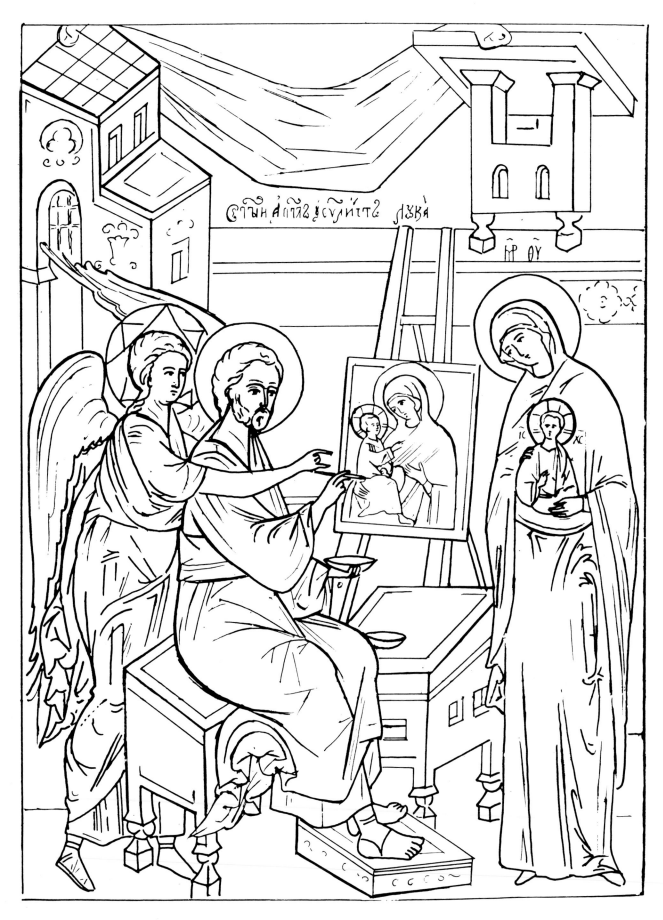

Line drawing of St Luke the Evangelist painting an icon of the Virgin and Child. He was believed to be the first icon painter, and various images are attributed to him. Based on a sixteenth century Russian icon.

Introduction

In the West today there is a growing interest in icons, but for those who wish to study the technique there is little information available. This book is presented as a step-by-step practical course, based on the author's experience of teaching in a London studio. The history, symbolic meaning and purpose of icons is a fascinating subject, which will give those learning the technique a necessary understanding of this special form of sacred art.

The Greek word icon (*eikon*) means image, and it usually denotes religious paintings on wooden panels in Byzantine style, either Greek or Russian. The Byzantine empire was a continuation of the Roman Empire in the East, and Byzantine icon painting is an art form which flourished throughout the immense territory of the empire. The capital, Constantinople (Istanbul) was founded as the New Rome in 330. It was built up on the ancient site of the Greek town of Byzantium, by the Emperor Constantine, who in 313 had adopted Christianity as the state religion.

At that time there were already great cultural centres such as Rome, Alexandria, Antioch and Ephesus. During these first centuries an early Christian art form had evolved. In Christian synagogues on the Euphrates, and in the catacombs in Rome, painting had developed a language of symbols, of Old Testament narrative, and a Christian re-interpretation of pagan images.

By the fourth and fifth centuries Byzantine art had reached its "first Golden Age" (or "early" Byzantine period), which culminated in the Emperor Justinian's architectural masterpiece, the church of Aghia Sophia (Holy Wisdom) in Constantinople. This city was to become famous for its magnificent buildings with their sumptuous decoration.

The best surviving mosaics of this period, however, are in Ravenna, former capital of the Western Empire and then seat of the Byzantine exarchate in Italy. The splendid mosaics at San Vitale depict the Emperor Justinian at his court. An official court art form developed in accordance with rigid concepts, for the glorification of both the Emperor and the Church, of which he was head. At that time mosaics were held in far greater esteem than frescos or paintings on wood. The earliest surviving icons date from the sixth century and were painted in encaustic (hot wax). Also from this period are the first known beautifully illuminated Gospels and some exquisite carvings in ivory.

This was also a period of great spiritual energy generated by the many church councils, like that at Ephesus, where the Virgin Mary was proclaimed *Theotokos*, or Mother of God. Early in the seventh century the Virgin became the protector of Constantinople, starting an important cult strongly connected with the veneration of icons. Her icon had been

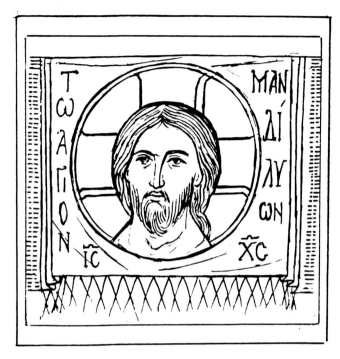

The Mandylion, "Holy Visage" or the Saviour Acheiropoietos (image "made without hands", Mark 14:58). Drawing based on a twelfth century prototype (fresco) in Panagia Phorbiotissa, Asinou, Cyprus, and a detail from a Constantinople icon (circa 944) in Sinai.

shown to the besieging Avars during one of their attacks, and had driven them away.

The evolution of Byzantine art was soon to be disrupted by the crisis of Iconoclasm (726–843). During this period imagery was prohibited and most images were destroyed or whitewashed. This crisis shook the Christian world in the East. It reflected the conflict between the aniconic traditions such as the Semitic and Islamic, which prohibited the use of imagery, and the Greek where the representation of images was vital. Finally, however, it established the legitimacy of venerating icons, as opposed to worshipping them, which was considered the cause of God's disfavour, resulting in the plight of Byzantium at that time.

The principal argument in defence of the icon was the tradition that tells of the impression of the face of Christ on the *Mandylion* (the veil of "Veronica" meaning "true image"), which was put upon the cloth by Christ himself. This was, according to the legend, the first icon, or "prototype", painted without human hands. (A tradition tells of an artist, sent by King Abgar of Edessa, who had indeed found it impossible to paint the divine features of Christ.) This impression upon the *Mandylion* is the origin of the Icons of the Holy Face of Christ or "The Saviour Acheiropoietos: image made without hands", (Mark XIV, 58: "I am going to destroy this temple made by

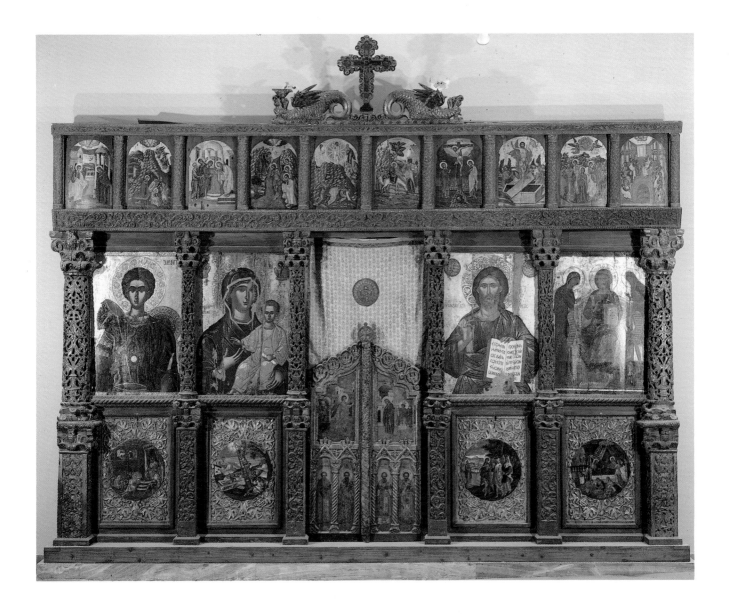

human hands and in three days build another, not made by human hands").

One of the most important theologians who defended the use of imagery during the crisis of Iconoclasm was St John Damascene – John of Damascus – (675–749), who compared the sacred pictorial "language" of the icons to the theological narrative function of the gospels.

When Byzantine art was eventually restored, the function of icons as visual theology, as an integral part of the liturgy, was consolidated. The late fourteenth century icon, on pages 72 and 73 was painted to celebrate the Feast of "The Triumph of Orthodoxy". A renewed fervour gave rise to a "second Golden Age" (or "middle" Byzantine period) from the ninth to the twelfth centuries (Macedonian and Comnene dynasties). The mosaics of St Mark's in Venice, and many in Sicily date from this time. There are also a number of beautiful portable miniature mosaics on panel, and some icons were preserved in Mount Athos and Sinai.

In the early thirteenth century, Constantinople was for a time ruled by the Venetians and the Crusaders. Icons from the Holy Land show an interesting mixture of styles during this period. By the fourteenth and fifteenth centuries (Palaeologan dynasty), icons in Constantinople had reached a high level of artistic accomplishment ("third Golden Age" or "late" Byzantine period). Characteristic of this school is the beautiful processional icon of the Annunciation, a copy of which can be seen on the front cover of this book with the original on page 1. (Detail page 61). On the reverse of the original is the icon reproduced on page 29.

Byzantine influence spread to Russia (converted to Christianity in the tenth century), culminating in the exceptional work of the Russian monk Andrei Rublev

The Virgin of the Sign. Drawing based on a fourteenth century fresco and a mosaic in St Saviour in Chora (Kahriye Camii mosque).

(circa 1360–1430). The Russian Orthodox Church, in its Council of One Hundred Chapters (1551) decreed that icon painters should take example from the work of Rublev.

In 1453, Constantinople fell to the Ottoman Turks. This marked the end of the Empire, but Byzantine influence continued, and from the early sixteenth century, Crete became the principal centre of Greek icon painting. For many centuries Byzantine art had a considerable influence on sacred art in Europe. In thirteenth century Italy this could already be seen in the work of Cimabue and Duccio, and it was the basis from which early Italian painting in Florence and Siena was to develop.

Byzantine churches, like Aghia Sophia in Constantinople, are built in the form of a Greek cross, with a dome over the centre. The form of the architecture and the symbolic placing of images confer a cosmological conception of the Reign of God on earth throughout the scheme of the building. The central cupola, for example, contains the image of Christ Pantocrator, while the apse contains that of the Virgin in an attitude of prayer ("*orant*"), as shown in the illustration above.

An important feature of the Byzantine Orthodox Church is the wooden icon screen or "*iconostasis*" which displays the icons (see page 8). This screen separates the nave from the sanctuary and has a central door ("Royal doors") which carries an image of the Annunciation and often of the four Evangelists. At either side there is an image of Christ (see page 42) and of the Virgin and Child (see page 35). These are the two icons we shall be learning to paint. The Royal doors are used on different occasions during the liturgy, sometimes remaining open, sometimes closed, according to the rite of the Byzantine ceremony in which the Eucharist takes place. (They are open during the processions, the reading of the epistle and gospels, and from the communion of the faithful until the end of the liturgy. At other times the doors are usually closed to enhance the sense of mystery according to custom.)

The first icon screens (*iconostasia*) were quite low and made of stone or marble. Icons first appeared along the top, on a wooden icon beam, in the eleventh and twelfth centuries. Later the whole screen became covered with icons, and in Russia the many tiers of icons reached splendid heights.

As icons are an essential feature of the liturgy, they are also placed on lecterns (or *Proskynetaria*) for veneration, especially on feast days.

It would be interesting for the student to compare the development of the Orthodox *iconostasia* with that of the altarpieces of Gothic and thirteenth century early Italian art. There are numerous collections of icons in museums throughout Europe, e.g. in the British Museum, London; museums in Athens, Venice, Ohrid in Yugoslavia; in the monastery of St Catherine on Mount Sinai and museums in Moscow and Leningrad. The student should also visit Orthodox churches with good examples of early *iconostasia*, in order to understand the role of icons in the service.

Icons are not only venerated in churches, however. In many Orthodox homes they are an integral part of the family "prayer corner".

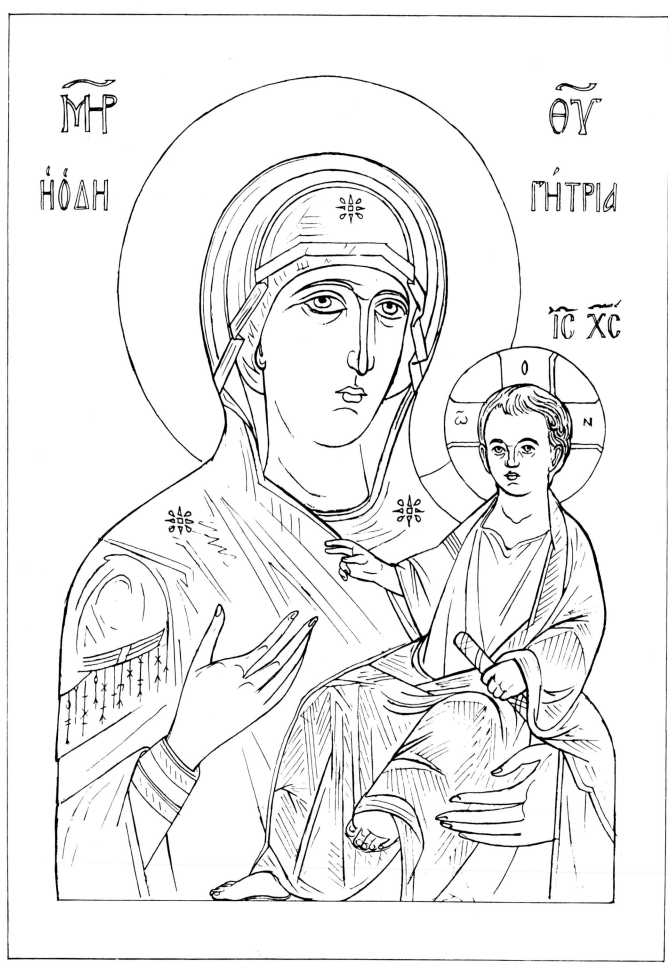

Line drawing for the icon of the Virgin "Hodigitria" and Child on page 35.

Icon students, including members of various religious orders, attending a course
at Cork Municipal Museum, Ireland, 1983.

The icon painting studio

An ancient tradition describes the Evangelist St Luke as the first icon painter. Several early icons of the Virgin and Child are attributed to him. Later icons depict him at his easel painting, with an angel guiding his hand (see page 6).

For centuries icons have been painted in workshops in the quiet and contemplative surroundings of monasteries. Different stages of the work were executed by members of the religious community working as a team, perpetuating the tradition of a particular school under the direction of a master. Sometimes the master and his apprentices would travel from town to town painting the icons in newly built churches, as in the case of the Russian monk Rublev in the fifteenth century.

Today, the icon tradition is more often carried on by experts working alone on commissions for churches or private homes. They may be reviving early models or prototypes dating back to the fourteenth or fifteenth centuries when icon painting was at the height of its artistic splendour, or they could be working on a modern version of a traditional icon.

For the icon student working in Western Europe, under the pressures of life in a busy city, it is first necessary to create an atmosphere conducive to inner peace and concentration. Time must be set aside to work without any outside interruption. It is important to have good light, a suitable table and all the appropriate equipment, reference material and reproductions of icons. The atmosphere can be enhanced by listening to recordings of Byzantine Orthodox liturgy, or if you prefer it, Gregorian chant, or even classical ecclesiastical music, such as Monteverdi, Vivaldi, Handel, Mozart, Haydn or Bach. Some students like to begin by reading from the Scriptures, lighting a candle and burning church incense. This helps to create the calm atmosphere required for concentration.

The painting of an icon is the opposite of subjective expression since it requires identification with a tradition. Moreover it is a discipline requiring a dedicated and humble attitude. For more advanced work, and particularly in the later stages of painting an icon, some fasting and spiritual exercises are a great help – that is, if you are already a good painter!

Drawing exercises

Before choosing and preparing the wood which is to serve as a base for your painting, it is advisable to practise your drawing techniques and to learn a little about the style, geometry and composition of the icons you will be working on. Read through this section before starting work on your drawings.

Drawing a half-length figure

The half-length figure is one of the easiest subjects for the beginner to start work on. First gather your drawing materials together.

Materials

For your drawing exercises you will need the following: a 2B or 3B well-sharpened pencil, tracing paper, a putty rubber for corrections and a pad of layout paper, size A4 or A3, or ordinary typewriting paper for the preliminary drawings. You will also need to practise drawing with fine sable brushes (round or "rigger"), sizes 0, 1 and 2, on the same paper, using a tube of raw umber watercolour. The length of the brush hairs should be 1.25cm (½in). A good selection of colour reproductions for reference is also required. The student should always carry a sketchbook when visting museums, churches, etc. in order to record valuable details. This will provide excellent reference material for future icon painting.

Preliminary exercises

Before you begin painting you should become acquainted with the style of the original icon and this is best achieved by continual drawing. To begin with we shall be working on two icons: one of the Virgin and Child (see the finished icon on page 35 and the drawing on page 10) and one of Christ (see the finished icon on page 42 and the drawing on page 15). Compare carefully the finished paintings and the drawings made for them. I suggest that you begin by drawing from the two finished icons, without referring to the drawings in the book, then compare the illustrated drawings to your own to see how you are getting on. (Guide lines may be used, see "Composition" on the opposite page.) If you have difficulty drawing freehand, place tracing paper over the reproductions and make two perfect tracings; then make the comparison. When you are confident that the drawings compare well, make one final drawing of each icon.

These two finished drawings will be transferred on to gesso-coated wooden panels and they therefore have to be the same size as your intended icon. Although the finished icons of the Virgin and Child and Christ *Pantocrator* (Almighty) measure 38 × 27cm (15 × 10¾in) the student will find it easier to work on smaller sized icons, i.e. 31 × 22cm (12¼ × 8¾in). The reproductions in this book are smaller, so

A nun drawing the icon of the Crucifixion

use a photocopier to enlarge your drawing or tracing to the required size.

You will have to be a great artist to get the final lines and proportions correct first time! It is easier to begin in a fluid, freehand or sketchy manner in order to establish the general composition. As work progresses make adjustments and necessary corrections, refining the drawing and eventually defining the final lines. Emphasize the outer silhouette of the image and the inner contours that define the different areas of colour, for you will depend on these lines when painting the background colours.

When you have finished your first pencil drawings, practise going over these same drawings with a fine sable brush and raw umber. This will develop the steady hand which is essential for painting.

Note

Some professional icon painters do not draw the image on paper first. They draw it freehand with fine brushes, directly on to the gessoed panel. The palm of the left hand may be used as a palette to mix a pigment, such as yellow ochre, with water. Unwanted lines are simply washed off with water. For this type of drawing a lot of experience is required.

Composition

Underlying the composition of an icon there is a subtle geometry of pure forms: curves (circle), verticals and horizontals (square), and diagonals (triangle). These are all interwoven into a harmonious whole or unity, a language of sacred geometry (see pages 60–63). You could indicate the centre of the icon with a vertical line before beginning to draw;

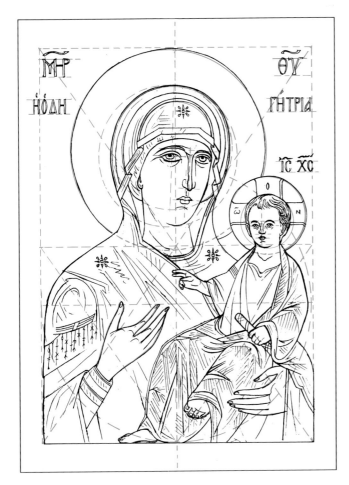
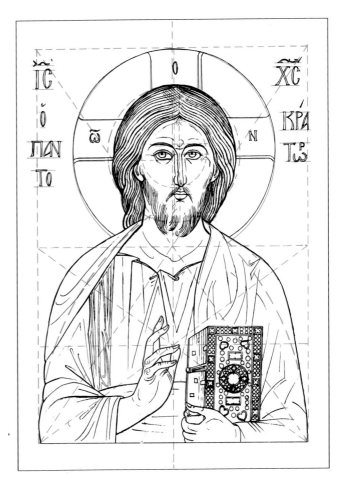

Geometric figures underlying the drawings of the Virgin Hodigitria and Christ Pantocrator (see pages 10 and 15).

also, if you find it helpful, you could square up the composition by superimposing a piece of transparent tracing paper on to your reproduction and drawing a series of vertical and horizontal guide lines to refer to in your own drawing.

Borders

The outer borders, or margins, around the image are an important element in the icon, since the painting of the figure never starts at the edge of the panel. The top margin must allow space for the halo and lettering. Margins may be the same all around, or the bottom and top margins can be slightly wider. These margins are not meant to be an ordinary frame, but the necessary space between the edges of the panel and the holy image, a sort of introduction to isolate it from the mundane world. Make sure you allow for these margins when planning your composition.

Style

The art of painting an icon requires a special language removed from a naturalistic imitation of life. It is a form of visual theology translating the Holy Scriptures. This is why it is said that icons are not painted but written, and why in churches icons are frequently placed on lecterns. The drawing technique is similar to the strict discipline required when working on calligraphy. The image must be translated into precise lines. These lines vary in thickness defining the form with its subtle configurations and geometric patterns. The drawing is completely linear without shading or shadows.

As you practise drawing, try to memorise the way faces, clothing and other features are represented, so that eventually you will become fully conversant with the style. Never draw an icon in a hurry or in a lighthearted simplistic manner like a caricature. This would destroy its spiritual feeling and dignity.

Words in icons

In the drawings and final paintings of the icons of the Virgin and Child, and Christ (see pages 35 and 42) you will see a series of letters. The words in icons are an integral part of the design. Unless the name of the holy person is depicted, the icon remains incomplete. This feature is in keeping with Eastern traditions of, for instance, Egypt or Islam, where the written word is an essential part of the visual language. The actual positioning of each word and the shape of each letter must be considered. The names or words in icons are often abbreviated, divided up and freely distributed at either side of the figure. When drawing, the style of the letters must be consistent with the school (Greek or Russian) and the period of the icon. The character of the letters varies from one century to the next and in later periods becomes more ornamental. The Byzantine alphabet differs slightly from modern Greek. The meanings of the Greek letters on the icon of the Virgin and those on the icon of Christ are shown on page 75.

The Virgin has three stars on her mantle. These are symbols of virginity before, during and after giving birth. Where Christ or the saints are depicted holding an open holy book or scroll, these contain texts taken from Scripture, and it is important to show the text correctly. In other cases, the title of the scene or a quotation of a particular saint is written.

Working from reproductions

With the passage of time most of the beautiful old Byzantine icons have suffered a certain amount of damage, such as cracks, blurred contours in the image, flaking paint and sometimes darkened or even missing sections. The idea is not to imitate the damage, since we are not trying to make fakes, but to get as close as possible to the beauty of the icon as it was originally painted. Reproductions often show sections of an icon and leave off some of the borders. Also frequently the colour of a particular icon may vary slightly from one reproduction to another. When sections are missing, or not clear, consult other reproductions of the same subject for comparison and reconstruction, always making sure that other icons used for reference are from the same period and the same school. This becomes an interesting part of the learning process.

During the early stages of your study I recommend that you concentrate on the study of icons of the Constantinople fourteenth and fifteenth century style, before venturing on to icons of other schools and other centuries. You will then understand how icons were painted at the height of the Byzantine tradition.

Tracing from reproductions of old icons

This is not advisable until you have had a lot of drawing practice and thoroughly understood the characteristics of the style of the icon. First make a perfect tracing of the colour reproduction using transparent paper. This tracing, if it is good, can then be enlarged by photocopying it to the required size of your panel.

Other studies

When you have finished your first two drawing studies of the Virgin and Child and Christ, you can choose another half-length subject, such as an angel, an apostle, an Evangelist or a saint (see pages 43 and 17, 16, 23 and 43 respectively). This will enable you to practise drawing heads, folds, letters and other features before embarking on whole figure compositions.

Further notes on drawing

Folds: when drawing folds in drapery you will discover that the shapes enhance the gestures and meaning of the subject. Although they are represented in an abstracted geometric style the folds are never arbitrary – or fantasy shapes; they make logical sense, and where the garment touches the holy body it radiates energy and light.

Hands: hands and fingers, and their gestures should be carefully studied. Their shapes are far from naturalistic, having a special representation in the Byzantine tradition. The position of the hands and fingers has deep symbolic meaning. They are either blessing, praying or pointing to God.

Faces: the faces in icons are not ordinary portraits, but depict the divine presence in man. Heads are never painted in profile since the Word of God has to be received face to face. The top of the head approximates the form of a circle and in turn is surrounded by the halo; the circle being the symbol of perfection, unity and totality, that which is holy, or God. The eyebrows form a bridge across the top of the nose, and the carefully shaped eyes are contained within the contours of the eye-sockets. The line of the nose ridge ends in an oval tip and is continuous with the nostrils. The special configuration of the lips must be sensitively drawn. The ear-hole and lobe are always shown uncovered, as the figure is listening. The neck is always visible, with a line indicating the Adam's apple. In a holy figure the five senses are symbolically depicted and interrelated. The ears listen to the Divine Word, the nose senses its perfume, the mouth speaks, praising it, the hands point out its beauty, goodness and truth, and the eyes contemplate its mystery.

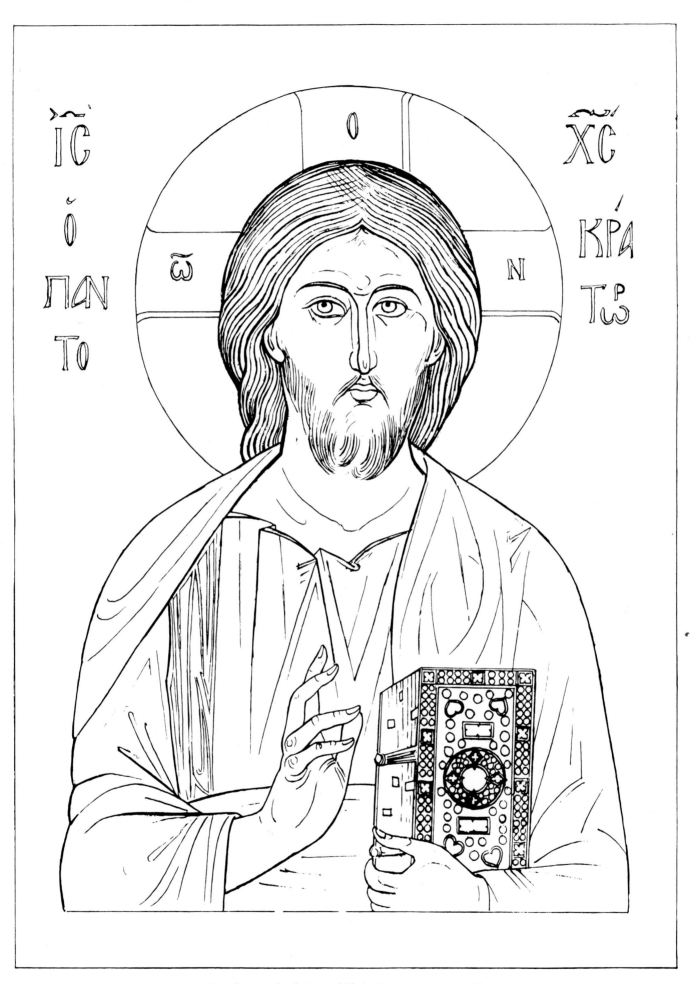

Line drawing for the icon of Christ Pantocrator on page 42.

15

The wooden panel

This section shows how to prepare the icon board for painting. You will need two wooden panels and three sample boards to carry out your first exercises on the icons of the Virgin and Child and Christ (see pages 35 and 42).

Materials

Two perfectly cut, clean 31 × 22cm (12¼ × 8¾in), 2cm (¾in) thick, blockwood panels (wood made up of plywood enclosing thin strips of wood). If blockboard is not available, you can use thick plywood 2 or 2.5cm (¾ or 1in) thick. (Do not use waterproof plywood, such as marine ply or exterior ply, because the layers are glued with a waterproof glue compound which makes the wood non-absorbent).

Three panels of similar or smaller size, one to be used for colour exercises (see page 28) and two for making samples for each icon whilst painting. These three panels could be made of thin plywood and only one side of each will require a gesso preparation (see page 19).

Solid wood

Well-seasoned solid wood, such as cypress, poplar, oak, beech, alder or lime could be used, but it is expensive and not readily available in the required size. This wood is available as narrow planks which have to be glued together by a carpenter to make a panel, with two wooden spleens slotted into the back. These spleens allow for slight movement of the wood with the passage of time, and must therefore be fitted without glue or screws. This device is often found at the back of icons.

Wood may warp in unpredictable ways, especially with the application of many coats of gesso. Soft woods are particularly susceptible. The old masters knew that the best cuts came from the centre of the trunk where the growth rings are symmetrical.

Note

If joined wooden planks are used, a thin cloth such as well-washed cotton, gauze, or very thin linen, must be glued on to the front of the panel to prevent cracks in the gesso due to any future movement of the wood, (see "Notes" opposite).

Unsuitable materials

Icons are not painted on canvas over stretchers, because the canvas would move slightly during painting, cracking the layers of gesso. Wooden panels are more rigid, in spite of the possibility of warping.

Very hard woods, such as mahogany, are seldom used and are only suitable if their smooth surface is roughened to hold the gesso. Reconstituted wood, such as composition board, medium density fibre board (MDF), chipboard or hardboard are not suitable since these artificial compounds contain resins and varnish and are not absorbent. Make absolutely sure that the wood is not dirty or greasy and has not been sealed with varnish or paint. This will prevent the coats of gesso from adhering and create cracks.

Rectangular pieces of solid wood are available, as breadboards or chopping boards, but these are often made of joined pine wood and are likely to warp. Furthermore, they have rounded corners and are frequently coated with varnish.

Do not use a warped panel or you will have difficulties laying down the colours. A slightly warped solid wood panel can sometimes be made flat by laying it on a glass table, with the concave side face-down over a damp cloth. Leave it for a few hours, or overnight; but if a piece of wood has this tendency to warp, it would be better not to use it.

Raised borders

Raised borders are often found in old icons, but are less common in nineteenth and twentieth century panels. They protect the actual image and provide further separation between the holy subject and the mundane world. Icons give a cosmological sacred vision of the universe and as such are self-contained temples or mirrors to the realm of the great mystery. The advantage of raised borders is that a cloth-covered ruler or stick may be placed across the icon to support the hand whilst painting.

Raised borders will not be required for your first, or even more advanced exercises. Later on they can be constructed on blockboard by simply gluing on a window mount of thin cardboard made of compact grey wood pulp, such as the cardboard backing on sketchbooks and painting pads (not the card used in ordinary picture mounts). Alternatively strips of cotton or linen canvas can be glued around the edges.

Very thin 2–3mm (⅛in) strips of wood (e.g. balsawood) may be used. These must be glued using a vice, for nails and screws would show through and crack the later coats of gesso. To prevent cracking where these wooden strips meet the panel, the inner edges must be chamfered off and narrow strips of thin gauze glued all along the joins. The rest of the surface is now covered with thin cloth or gauze. This is glued on in strips (which should not overlap each other, or those covering the border join) so forming a single layer over the entire surface. This method was used in the icon of the Annunciation on the front cover.

In old icons the borders were obtained by carving out a shallow recess in the centre of the solid panel. This technique is still used today but it is a laborious and skilled process.

Raised borders are in any case inappropriate for learning the basic technique. Leave them for your first important commission!

Glue size

When the five wooden or blockboard and plywood panels are ready, they have to be prepared with glue size. This penetrates and seals the wood, ready for the gesso application.

Materials

Two packets of edible gelatine, 11gms (⅓oz) each, (available from your grocer or supermarket); a small measure such as an egg-cup or film spool container (large enough to hold two small packets of gelatine); a saucepan; a tablespoon; a 5cm (2in) wide, flat decorator's brush.

Preparation

Put one measure two 11gms (⅓oz) packets of the powdered gelatine to soak for a few minutes in a saucepan, with seven measures of water. Heat it slowly and stir continuously (to prevent it burning on the bottom of the pan) until thoroughly dissolved and hot, but not boiling.

Application

Now brush the gelatine solution over the panels, thinly coating the front, sides and back, in order to seal the grain of the wood completely. Wipe off any excess gelatine with a clean rag. Throw away the remaining solution and clean the brush in hot water. Allow the panels to dry thoroughly for a few hours, or overnight, in a well-ventilated room. It is best to lean them diagonally against a non-absorbent surface (glass or tiles) so they will not stick, and the air can circulate round them during drying. The panels are now ready for the gesso ground.

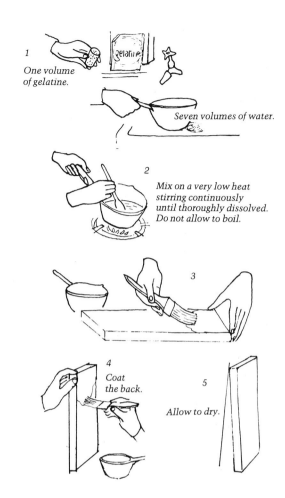

1 One volume of gelatine.

Seven volumes of water.

2 Mix on a very low heat stirring continuously until thoroughly dissolved. Do not allow to boil.

3

4 Coat the back.

5 Allow to dry.

Notes

If the glue-gelatine solution is allowed to cool down it will become a jelly and will be impossible to manipulate with the brush. It would need to be re-heated again before use.

Do not attempt to dry the panels near a radiator as the wood will warp.

If you are using a large panel you can coat the front and sides first and leave it lying on a table to dry. It can then be turned over and coated on the back.

If gelatine is not available, fine granulated rabbit-skin glue could be used instead. This is prepared in the same way as described above for the gelatine.

If you wish to glue a thin cloth over the front of the panel, recoat the surface with glue-size when the first coat is dry. Place the cloth evenly over the panel while the size is still wet, removing any wrinkles or air pockets by pressing firmly with your fingers. Coat over the cloth straight away with more size, so that it is well impregnated, and then leave to dry.

Gesso ground using whiting

The gesso ground, because of its qualities of absorbency, white luminosity and smoothness, is an ideal base for egg tempera painting. This ground is applied in a series of whiting/glue coatings over the wooden panel. The panel, sized with gelatine glue, must be thoroughly dry before the gesso is applied. Each icon panel will require approximately 2–3 packets of gelatine for the gesso layer. The smaller panels will require less as they only require gesso on the front.

Materials

Several 11gm (⅓oz) packets of gelatine powder; a small measuring phial; a saucepan and tablespoon; a large bag (approximately 2kg/4.4lbs) of good quality white whiting, free from impurities (this can be bought from a supplier of gilding materials or from an art and craft or hardware suppliers); a 5cm (2in) flat decorator's brush; several sheets of sandpaper (such as glass paper) of different grades – medium-rough, medium, medium-smooth, smooth and very smooth (or "flour paper"). An artist's flat palette knife and a metal filing rasp would be useful.

Preparation

Wear an apron! The work is quite messy with a lot of dust produced during sanding down. For this reason the table or work bench should be in a well-ventilated room. This operation could take a whole day.

Prepare a glue-size solution exactly as shown on the previous page, but this time use one measure of gelatine powder (a small packet) to twelve measures of water. When the gelatine has dissolved and is hot, remove it from the heat. Take out one tumblerful and put the remainder aside in another saucepan for "stock". Return the glass full of warm gelatine solution to the saucepan and add to it 2–2¼ measures of whiting powder. Use a dry glass, tapping it on the table to settle the powder before topping it up (see the drawings).

Mix the whiting in well for two or three minutes, stirring with the spoon and pressing out any lumps against the sides of the pan, until the mixture is smooth (a bit thicker than single cream). A fine sieve could be used if necessary to filter off any lumps. This creamy mixture of gelatine-glue and whiting is called gesso and it is now ready to be applied to the panels.

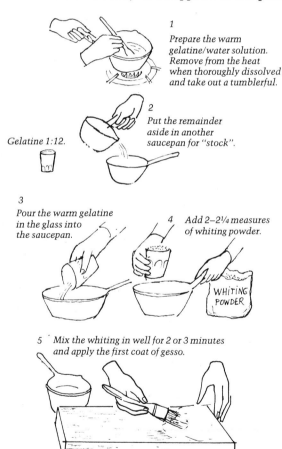

1
Prepare the warm gelatine/water solution. Remove from the heat when thoroughly dissolved and take out a tumblerful.

Gelatine 1:12.

2
Put the remainder aside in another saucepan for "stock".

3
Pour the warm gelatine in the glass into the saucepan.

4 Add 2–2¼ measures of whiting powder.

WHITING POWDER

5 Mix the whiting in well for 2 or 3 minutes and apply the first coat of gesso.

Application

Coats 1 to 3: brush the gesso solution on to the front, sides and back of your two icon panels, pressing vigorously against the grain of the wood. Only coat the front of your "sample" panels. If the solution is

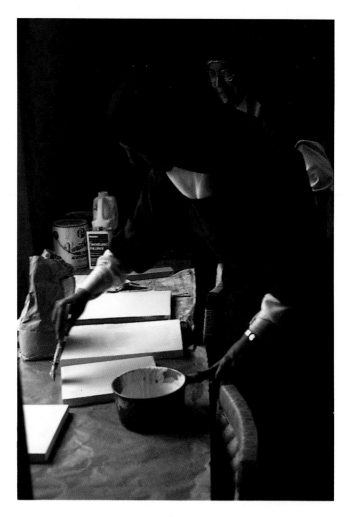

Nuns preparing gessoed panels during an icon course at the Benedictine Monastery of Christ in the Desert, Abiquiu, New Mexico, U.S.A.

too thick, simply add a little glue from your "stockpot"; if it is too liquid just add more whiting. Never just add water to the mixture or you will alter the proportions of the glue. These first coats should be evenly applied but need not be absolutely smooth. It is preferable for brush marks to show in order to provide a "tooth" for subsequent coats. For this reason it is also better to criss-cross the brush in different directions when applying each coat. To dry the first and subsequent coats, lean the panel diagonally against a surface where the air can circulate around it (as for the glue-size see previous page).

After about twenty minutes, when this first coat should be dry to the touch, vigorously apply a second coat, and twenty minutes later a third. Throw away any remaining whiting solution (or the dried gesso will have to be scraped off your saucepan) and clean the saucepan and brush.

Coats 4–6: three hours later prepare the 1:12 gelatine solution again by reheating the "stock". Remove from the heat and add the whiting powder as before. Apply three coats as before and leave to dry for six hours or

overnight. This longer drying period is necessary because although the panels are dry to the touch, the dampness beneath is still penetrating the wood.

Coats 7–9: prepare more glue-size solution with the gelatine and whiting as shown in the "Preparation" section, and apply another three coats exactly as before. The consistency of the gesso could be more fluid at this stage: two measures of whiting to one of glue-size. Clean the saucepan and brush and wait for three hours this time.

Coats 10–12: you are now ready to apply the last three coats at twenty minute intervals as before. The gesso consistency could be still more fluid, with only one measure of whiting to one of glue-size. The idea is to obtain the smoothest possible finish. This means that you will have to work smoothly with the brush, or an artist's flat palette knife, to cover any brush marks, small grooves or gaps.

Sanding

After about three hours, or the following day, start sanding down the gessoed panel. Be sure to wear your overall and put dust-sheeting/newspaper on the floor; alternatively work outside.

First use a metal rasp on the sides of the panel if they are rough. Start with medium-rough and then medium sandpaper on the front, sides and back of the gessoed panel. Remove any excess dust on the surface with a dry brush. Continue sanding with smoother grade sandpaper, looking against the light for small imperfections. If you spot any grooves you may need to revert to the rougher sandpaper. Finally, use the finest sandpaper, or "flour" paper, to give an absolutely smooth finish. Double check the finished surface by going over it with a clean soft cloth, slightly dampened, to pick up any remaining dust. If the result is not perfect, you may have to apply another thinner coat of gesso solution and sand down again. As you will see, this is a tiresome, but nevertheless rewarding operation, for now the panels are ready for you to start your colour work in icon painting.

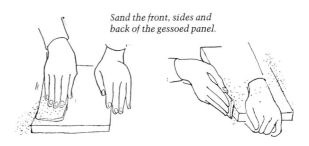

Sand the front, sides and back of the gessoed panel.

Notes

If a cloth has been glued on to the panel (see page 19) apply the gesso in the same way as above.

If solid wood is used, only the front of the panel is gessoed (as it is good to see the beauty of the solid wood at the sides and back of the icon).

We have discussed the gesso as applied in a series of twelve coats, but it is even better to have fifteen or eighteen coats, particularly if these are thin. Be careful to maintain the consistency of the glue mixture, for a slightly stronger solution may lift off previous coats of a weaker solution. Some artists prefer to vary the consistency of the coats, gradating from a glue:water solution of 1:8, 1:9 and 1:10 to 1:12 for the final coats.

If the whiting powder is added while the glue-size is being heated, it will produce bubbles and create air or pin-holes in your gesso coatings. Pin-holes in gesso can be removed by covering them over with more gesso on a palette knife, or by dampening the surface slightly with water and going over it with wet-and-dry sandpaper.

Rabbit-skin glue in granules, or parchment glue (available from a good art material supplier) can be used instead of gelatine glue, in the same 1:12 proportion, but gelatine is the standard glue for gesso.

If you have not succeeded in priming the gesso smoothly on to the panel and it is lumpy, you can wash the panel under hot water and once it is dry, start again.

If the gesso is not adhering to the panel and cracks are occurring, it is probably because the wood is primed with varnish, although it may appear to be unvarnished. You will have to start again with a new clean panel. Cracks on gesso may also occur if the layers are too wet or the concentration of gelatine in the solution for the final coat was too strong.

In the old days the gesso coats applied first were of plaster of Paris mixed with glue. (Today, dental plaster, available from chemists, is the best type.) This was called "gesso grosso" and was followed by many coats of "gesso sotile" which was slaked plaster of Paris. Slaking plaster of Paris is a lengthy operation. The powder is sprinkled into a very large bucket of water and stirred constantly for six to nine hours to prevent small lumps of plaster from setting. The powder is then allowed to settle at the bottom of the bucket and the excess water is thrown away. The paste remaining is allowed to dry for stock, or is used in paste form mixed with the glue solution as the actual gesso. This gesso is more fine ("sotile") than the rough unslaked plaster of Paris. You may need to make it if whiting is definitely not available!

If water alone is added to the plaster of Paris it will set very fast and become quite unworkable with the brush; furthermore it would not stick to the wood. Gelatine glue or rabbit-skin glue, added to the plaster of Paris, acts as a retarder delaying the setting process. Gradate the glue:water solution as described above: from 1:8, 1:9, 1:10, 1:11 to 1:12 for the final coats.

Whiting is natural calcium carbonate, ground, washed and refined. Artificially produced calcium carbonate ("precipitated chalk") differs in density from whiting and is too light for gesso purposes. However, it can be used to make another type of gesso ground if it is mixed with artists' dry pigment powder in the proportion of one or two volumes of calcium carbonate to half of zinc white and another half of titanium white. This gesso is applied in the same way as described on these two pages.

In art shops other products are sold as "gesso", such as "acrylic gesso", but these are not suitable grounds for icon painting.

Although slaked plaster of Paris, and also gypsum (native or hydrated calcium sulphate), were used in the Middle Ages, and other gesso grounds could be prepared (e.g. a mixture of a slaked plaster of Paris and whiting), the gesso made with whiting is the simplest and is also perfectly adequate. There is no need to make life unnecessarily complicated!

Transferring the drawing and incising it on to the gessoed panel

The panels are now prepared with the gesso ground, their surfaces perfectly smoothed and absolutely free from dust. You have also made your drawings for the icons of the Virgin and Child and Christ, to fit the two 31 × 22cm (12¼ × 8¾in) panels. We are going to start with the icon of the Virgin and Child.

Materials

Non-greasy carbon paper, or a soft pastel or dry powdered pigment of a red earth colour such as burnt sienna or red ochre; masking tape; a fine ball-point pen; a small awl or a very long nail sharpened to a point on a whetstone.

To transfer the drawing

Place the piece of non-greasy carbon paper face down underneath your original drawing (or a good clear photocopy of it). Alternatively, rub the back of your drawing with soft pastel, or simply use your fingers or a soft cloth to smear dry powdered pigment of any colour (but preferably red earth) all over the back of your drawing.

Position your drawing (and carbon paper) carefully over the front of the panel and fix it along one side with masking tape to prevent it from moving. The other sides are only fixed in one or two places so that you can lift the side of the drawing to make sure that it has all been transferred. Go over the lines of your drawing, pressing with a fine ball-point pen to transfer the image on to the gessoed panel.

To incise the image

When this is quite finished, remove the drawing (and carbon paper) and start incising the lines of the drawing which have been transferred on to the gessoed panel. Use a fine, sharp metal point such as a small awl, or a very long sharpened nail. Compass points and dry-point etching needles are too thin.

This is an operation which requires patience, precision and a steady hand. As you "engrave" the gesso with your fine metal point, keep blowing away the dust. These incisions should be about ⅓mm deep and about ¼mm wide. You will depend on them as guidelines when painting since they will show through the first layer of colour.

The colour background

When the drawing has been incised on to the panel, you are ready either to gild or paint the background of the icon. This is usually gold, but it could be silver, off-white or red. The gold background can either be painted by hand with egg tempera, or gilded with gold leaf by the oil-gilding or water-gilding methods.

Painting the background

For your first exercises gilding is an unnecessary luxury; it also requires great skill. You can therefore paint the background colour with egg tempera, (see page 25), by mixing egg yolk and water with pigments to approximate a golden colour. This can be obtained with a mixture, in varied proportions, of cadmium yellow, yellow ochre, raw sienna, burnt sienna and titanium white, which can be applied in one layer, or in two thin layers by direct painting (see page 26). When mixing this golden colour for the background, bear in mind that it must harmonize later with the colours of the figure. It should have the right feeling and not be too heavy, opaque or harsh. Make several samples beforehand on your sample panel, using your colour reproductions as a guide.

Oil gilding

Instead of painting the background of your icon, it could be gilded. There are two methods: water gilding and oil gilding. Water gilding gives by far the most impressive result and can be very beautiful, for the gold leaf can be burnished to reflect the light, giving the appearance of solid gold. However, it is expensive, a lengthy process and it requires special equipment, patience and skill. Oil gilding is simpler, less time-consuming and does not require specialised equipment; therefore it is cheaper. It has a matt finish and cannot be burnished.

For water gilding the extremely fine square sheets of gold leaf are sold loose between sheets of paper in booklet form. For oil gilding these very fine square sheets of gold are stuck on to sheets of paper to be transferred by rubbing. This is "transfer gold leaf" as opposed to "loose gold leaf".

The student is advised to try the oil gilding method shown here first, before attempting the water gilding method described on page 44.

Materials

2 flat nylon brushes, 1cm (⅜in) and 1.5cm (⅝in) wide; 1 round nylon "rigger" brush no.3; a white plate for mixing colours; a cup of water to dilute the colours and for cleaning the brushes; acrylic colour; the finest

wet-and-dry sandpaper (optional); clear lacquer (optional); paper or tracing paper to make a template of the area to be gilded; a book of transfer gold (23¼ carat); small, sharp scissors; a ball-point pen, a sheet of non-greasy carbon paper; Japan gold-size. Instead of using real gold leaf you could use transfer metal leaf substitute. This is much cheaper but the effect is harsh.

Technique

Paint the background shape of your icon (incised on to your gessoed panel) with two or three thin, smooth, even layers of diluted acrylic colour using terracotta or red oxide, mixed with titanium white. Raw sienna could be used as an alternative to terracotta. Use the flat brushes for larger areas and the round brush for detailed work.

Be very precise when painting around the figure. Paint over the halo and letters. The colour surface must not show any brush marks or scratches; if it does, sand it with the finest wet-and-dry sandpaper, as these marks will show through the gold leaf.

The purpose of these layers of paint is to seal the gesso, making it non-absorbent, and to provide additional colour underneath the gold which increases its beauty. Wash the brushes thoroughly in water after use. For further sealing, paint a thin transparent coat of clear lacquer over the acrylic background colour when it is dry, using the same nylon brushes.

You are now ready to transfer the gold leaf on to the background colour. For this you will need a paper template (a cut-out shape) of the background. This could be cut from a photocopy or traced from the original drawing. In order to plan your gold layout, you must turn this template over. With clean fingers, (perhaps dried with a little talcum powder to prevent grease marks), use the scissors to cut the paper sheets from your book of transfer gold leaf. Lay the sheets with the gold facing upwards on the template (the reversed "pattern sheet") so the entire area is covered. Allow for a slight overlap at the joins. The squares of gold overlapping the figure must be cut to size with the scissors, but not too small. This will take some time and is like making a gold mosaic around the figure. Keep the off-cuts of gold for later icons.

When the layout is complete, you are ready to transfer the gold on to the icon. Paint over the colour background with one or two very smooth, thin layers of Japan gold-size, which acts as a "mordant". Whilst this varnish is still slightly "tacky", take your cut-out shapes of gold from your template one by one and transfer them on to the icon background by rubbing the paper backing with your fingers. Lift off this paper (without letting it, or your fingers, touch the varnish) leaving the gold in position.

You may now admire your first oil gilding, but do not forget to clean your brushes thoroughly with plenty of white spirit, soap and water. If you have lost the halo and lettering, they can be inscribed again by pressing through the drawing with a ball-point pen, provided this is done immediately. Patterns may also be indented on the gold, as described on page 48.

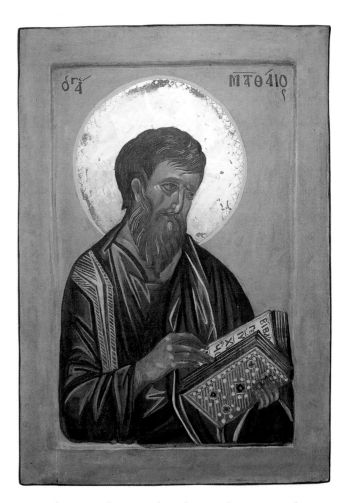

Evangelist St Matthew. Based on a fourteenth century icon by a Greek painter working at the Chilandari Monastery, Mount Athos. 36.5 × 27.75cm (14⅜ × 10⅞in). Original 100 × 69cm (39⅜ × 27¼in).

Notes

Instead of painting the Japan gold-size on as a mordant for the gold leaf, you can use garlic! Peel some garlic cloves, cut off the ends and rub firmly over the background to provide a slightly sticky base.

There are other gold-size mediums, including the "mixtion à dorer clarifiée" in "1 hour", "3 hours" or "8 hours". The surface must be non-absorbent and the hours refer to the time you must wait after application before transferring the gold. Mediums with a longer time-scale are supposed to be better, but I should not worry about this for your first icon.

The metal substitute gold leaf is used mainly on very large decorative panels. The colour is harsh compared to real gold and therefore is coated later with glue and brown pigment to "antique" or mellow its appearance. If you are working on a small icon the cost of real gold leaf is quite reasonable.

It is possible to gild the halo and not the entire background, or to gild the halo with gold and the rest of the background with a different shade of gold, with white gold or silver leaf.

A gilded effect can be obtained by coating the coloured background with a thin layer of Japan gold-size. Whilst this is still tacky, use a brush to dust it over with pale gold bronze powder (tarnish resistant) and when dry, coat it afterwards with clear lacquer.

The above notes give examples of decorative options that you may wish to consider at a later date.

Egg tempera technique

Icons are painted with egg tempera, which is a mixture of egg yolk, water and coloured pigments. This gives the colours painted on the perfectly smooth, absorbent white gessoed panel a beauty and luminosity of their own, which is enhanced by the gold of the background. With this medium it is possible to achieve fine details and precise lines.

Byzantine artists developed special methods of building up the painting in layers, from cooler dark or medium tones to warmer and lighter tones. This is most effective in the rendering of form and light-dark values. The technique differs from fresco, which is painted in layers from light to dark, and also from watercolour, which is painted from light to dark but always transparently.

Egg tempera painting, like encaustic and fresco, is one of the most ancient techniques. It was known in late antiquity and was used on panels and gessoed grounds in Europe from Hellenic times, and particularly from the Middle Ages up to the late fifteenth century. Icon painters have used it right up to the present day.

However, from the fourteenth century onwards, painting schools in Europe gradually started experimenting with other techniques. Canvas provided a support which was lighter and more malleable than wood. It required grounds more supple than the rigid gesso on wooden panels. Artists were experimenting with a variety of different media (mixtures of egg yolk with drying-oils and resins), and with different grounds (mixtures of gesso and oils) to make the surface less absorbent so that alterations would be easier. They were searching for less linear, more fluid, and at times even impressionistic ways of handling the paint on canvas and obtaining impasto effects. Eventually egg tempera was almost entirely replaced by oils.

With the development of humanism in the Italian High Renaissance, a new aesthetic evolved, quite different from that of the icons and this was to influence the thought and the art of the rest of Europe.

Today, many artists and art-lovers have become fascinated by the beauty of the ancient technique of

Layout of materials required for painting an icon.

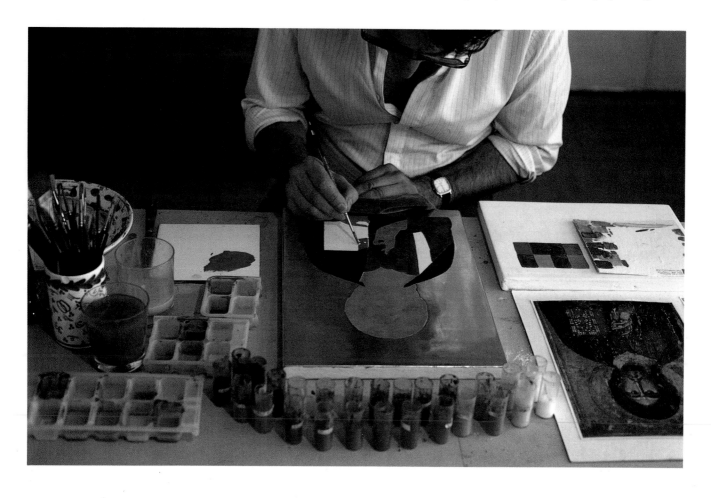

egg tempera used in old Byzantine icons. Although painted hundreds of years ago, the colours are still glowing with a life and luminosity that can never be achieved with oils. Moreover, oil paintings tend to become darker with age, whereas tempera paintings retain their original colour. This is due to the stability of the egg tempera medium and to the luminous quality of the gesso ground. Tempera, using egg yolk, water and colour pigments also makes an excellent paint for completing a watercolour painting.

Tempera technique can be used in a variety of ways and in accordance with many different recipes where egg yolk, water, oils and resins are emulsified. These tempera emulsions are often used as paint, or to work on fine details of oil paintings.

When visiting museums, if there are no icons on display study the egg tempera works of the Gothic period, the early Italian painters, such as Giotto, Duccio, Fra Angelico, the early Flemish school, or the secular work of some twentieth century artists, such as the American, Andrew Wyeth.

All painting techniques require a proper understanding of the qualities, possibilities and limitations of the medium. The study of icon painting will give the student an insight into how egg tempera was used by the great Byzantine masters with such skill, to achieve such beauty.

Egg tempera in icon painting – pigments and materials

The photograph on the page opposite shows the layout of materials required when painting an icon. If you have a restricted work surface, it is advisable to lay your materials out in this way for easy access and quick identification of colours.

A good art shop will supply small amounts of artists' dry-ground colour pigments; these are listed on this page. They can be transferred with a tiny spoon into 15ml clear plastic phials (available from most chemists) and labelled. You will need between twenty five and forty of these.

In addition you will need the following: an assortment of brushes; the egg yolk/water mixture (which is your painting medium); a white ice cube tray; a sample panel; a glass of water to clean the brushes; a large white plate (a piece of formica or a large white tile) for mixing colours; a piece of velvet or soft cloth to lean the hand on whilst painting.

The materials listed are discussed here in more detail.

Pigments

Lay out the pigments from left to right as shown in the photograph. The colours are organised into similar "family" groups, i.e. blues, reds, yellows, etc.

First row: lamp black, French ultramarine, cobalt blue, raw umber, emerald green, viridian, red ochre, carmine, cadmium red, cadmium orange, raw sienna, cadmium lemon, titanium white.

Second row: ivory black, indigo, azure manganese blue, chrome green, terra verte, madder deep, caput mortum violet, burnt umber, burnt sienna, yellow ochre, cadmium yellow, zinc white.

Additional colours can be used, see "Notes" (on pigments) on page 27.

Brushes

All small brushes for painting detail should be "best sable"; large brushes for larger areas should be sable or the less expensive nylon, ox, squirrel or pony hair.

Fine best sable (round or "rigger"):
Two each of nos. 0, 1 and 2, 1.25cm (½in) length hair.
Three each of nos. 3, 4 and 5; 1.5cm (⅝in) length hair.

Nylon:
Two each of nos. 8, 12 and 15 ("rigger").
One each of 0.5cm (¼in), 1cm (⅜in) and 2.5cm (1in) wide, flat (square edge).

Egg tempera painting medium

The egg tempera medium is a mixture of egg yolk and water. The proportions should vary throughout the four stages of painting, but a ratio of one volume of egg yolk to six of water would suffice for the whole icon.

First stage: (see page 31). The first layer of colour, or "petit lac", should be matt when dry. To achieve this, the amount of water could be approximately nine times that of egg yolk (1:9). However, some pigments require a more concentrated solution of egg yolk for binding, otherwise they may rub off slightly when dry. Other pigments require less egg yolk, and too much would make the colours glossy when dry. It is useful to make tests on your sample panel with different colour pigments, using different proportions of egg/water solution.

Second and third stages: (see pages 32 and 33). For the second layer of colour the proportion of egg to water is approximately 1:6.

Nourishing layer: (see page 33). This is a transparent coating applied at the end of the third stage to unify the layers of colour. It is a solution of approximately 1:12 without pigment.

Fourth stage: (see page 34). The final layers of colours are painted with a more concentrated solution of approximately 1:3, which makes the colours stand out against the matt or slightly silky background. The

halos, letters and highlights are painted with a 1:1 solution, which is ideal for fine detail.

These proportions are approximate, and with practice can be measured by eye. Simply add less water to the egg yolk for each successive stage of painting.

Preparation

In a glass mix a solution of egg yolk (without its skin) and cold tap water. Purified water is preferable, or boiled water. Measure the required proportions of water and egg yolk, as described, with a large tablespoon. Use very fresh eggs, preferably free range! Separate the yolk from the white (with a spoon if necessary), and place it on a paper towel to remove excess moisture. It should now be possible to pick up the yolk by its skin. Prick the skin and catch the yolk (hopefully) in a glass, or simply use a sieve.

The egg yolk solution will keep for about five days in a closed jar if refrigerated. A few drops of vinegar will help to preserve it.

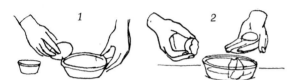

Crack an egg over the edge of a basin. Allow the white to fall into the basin and retain the yolk in the palm of your hand or in a paper towel.

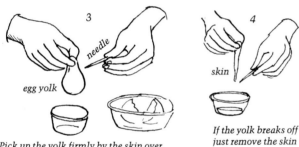

Pick up the yolk firmly by the skin over another (small) basin. Prick the yolk with a needle to allow the liquid yolk to fall into the basin without the skin.

If the yolk breaks off just remove the skin as best you can.

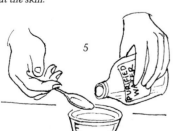

To the egg yolk add approximately 9 times its volume of purified water (or distilled water). Mix thoroughly.

The 1:9 concentration is only suitable for the first layer of paint. Further layers will require a 1:6 and later 1:3, 1:1 concentration approximately.

Mixing the egg tempera painting medium with pigments

Before starting to paint the two icons of the Virgin and Child and Christ Pantocrator, you should practise mixing pigments, and experiment with colour on your sample panel.

To mix the colours, pour some egg solution into several ice-tray compartments. Now you are ready to add the pigments. Choose your colour, wet a brush with the solution and pick up some pigment from one of the phials. Mix it well into the egg solution in one of the compartments. With the same brush, pick up other pigments of your choice one at a time and add them to the mixture contained in the separate compartments. These colours can quickly form a deposit and must be stirred just before painting.

You are now ready to make the first of a series of colour exercises on your sample panel. After each sample clean the brush in a glass of water, and with soap and water when you have finished. To mix colours in even smaller quantities, simply put some egg solution on to a white plate and add the pigment to it as described.

Methods of painting colours on to the figures

During the four stages of painting an icon several different methods of applying the paint are used.

Petit lac

"Petit lac" (little lake): this term refers to the first or base colour only and is applied by flooding the paint on to the gessoed panel with well-loaded "rigger" brushes of appropriate sizes from 8 to 15. The larger brushes are used for large areas and the smaller brushes for contours and awkward areas.

The purpose of flooding is to obtain an even layer of colour. This is achieved, not by spreading out the first "puddle" as it would then be too thin, but by adding a series of adjacent "puddles" which merge into each other ("petit lac").

Lean your hand on the velvet whilst painting and work from edge to edge to cover the whole shape, without leaving thin patches or brush marks. This operation should be done speedily, but it requires practice. Make sure you have enough colour mixed in your tray and keep stirring it to prevent deposits.

The colour will be absorbed into the gesso within ten minutes. It must not be too heavy or opaque (add some egg solution to your mixture) or too transparent or uneven (add more pigment to your mixture).

Direct painting

Instead of using the "petit lac" method, the first layer of colour could be applied in two or more thin coats, painted smoothly and carefully with flat brushes. The finished colour must be very even and free from brush marks (difficult to achieve with certain colours) as this is the base colour for painting the figure,

landscape and architecture. All subsequent layers of colour will be progressively lighter and warmer. The edges of the lighter colour against the dark beneath may be softened either by dabbing with a finger whilst still damp, or by adding water or egg solution with a brush.

Hatching and cross-hatching

This method is normally used in later stages of the painting. Colours are applied with fine sable brushes in a series of closely interwoven directional strokes, to create subtle gradations from light to dark and from dark to light. The fine brushes must not be loaded, but almost dry. Remove the excess colour by gently wiping the brush against your thumb. This will prevent the annoying little spots of colour that form at the end of each stroke.

Glaze

This is a thin, even coating of very diluted, semi-transparent or transparent colour, painted with a flat brush over another colour. It is applied in order to slightly change the hue or tonal (light/dark) value of the original colour.

Line painting

This is done over the background colours with fine sable brushes using the incised drawing as a guideline. The width and colour of these lines varies according to the design and the background colours. The sensitivity and rhythmic flow of these lines is an essential feature of the icon. (It is said that an icon is "written".)

Notes

Egg yolk is used in tempera painting for its excellent emulsifying, adhesive and drying properties. The egg white (pure albumen) is sometimes used for its adhesive properties. All these qualities are lessened by oxidation, i.e. air penetrating the egg shell over a period of time. (This is why it is important to use fresh eggs.)

Alterations: the gesso ground absorbs the colour almost immediately. It is therefore difficult to make alterations and tests should be made on your sample panel beforehand to avoid mistakes and accidents. Removing colours requires patience and care, to avoid damaging the gesso ground. If the colour is still wet it can be removed with a damp cloth or with your finger. If the colour is dry, it can be scraped off carefully, like a skin, with a blade or scalpel, taking care not to scratch the gesso. Colour can also be removed with a soft cloth slightly dampened with ethyl alcohol (ethanol) or surgical spirit. An alternative to removing the colour is to alter it. Glaze it with a transparent zinc white, and when the glaze is dry paint the correct colour thinly over the top.

Pigments: other useful pigments are
Expensive: genuine vermilion, cadmium red deep, genuine lapis lazuli, rose madder genuine, cobalt violet deep, genuine Naples yellow.
Inexpensive: crimson lake, caput mortuum, lead (flake or cremnitz) white, vine black, Prussian blue, vermilion light imitation azo, lead red minium, alizarin brown and additional earth colours of your choice.

The colour range: Byzantine artists used a range of pigments of natural origin. These were:
(a) earth or mineral, such as yellow ochre, terra verte, lapis lazuli
(b) animal, such as carmine and crimson lake (made from the dyestuff of the cochineal beetle)
(c) vegetable, such as rose madder (made from the roots of a plant)
Some of the colours they used are no longer available, or are made by a different process, or are simply too expensive. Today we have at our disposal a full range of new and artificial colours, such as cadmiums, cobalts, viridian, titanium and zinc whites. These are useful in certain mixtures if used with discretion. There are other new artificial colours, but we have not included these here as they are too harsh and would spoil the natural harmonies in the colour scheme of the icon.

Manufacturers' catalogues for artists provide information on the chemical composition, opacity, transparency and permanency of the pigments they supply.

Some colours are opaque with a high density of pigmentation and therefore have more covering power. Some are semi-opaque and others are transparent. For example, titanium white is opaque and in mixtures it tends to make colours dull and lifeless. Zinc white is transparent and when mixed does not affect the vitality of the other colours. Lead (flake or cremnitz) white is semi-opaque and was the standard white in earlier centuries. It is a poisonous, but useful, pigment.

With regard to durability, some colours are permanent, some are semi-permanent and others are non-permanent or "fugitive". The latter are of no use here and have therefore not been included.

Some manufacturers sell cheap pigments for decorating purposes. These do not have the purity and brilliance of the artists' range, because they have been "cut" or adulterated with "fillers".

Some colours absorb water readily, while others absorb it more slowly, remaining "gritty" until they are thoroughly saturated.

In professional icon studios handling commissions constantly, all the pigments are ground beforehand with purified water only. This is done with a flat glass muller on a piece of frosted plate glass or marble surface and is a painstaking operation. The paste is kept in air-tight jars and the egg/water solution is simply added to the paste at the time of painting. For our purposes, you can grind some of the more gritty colours (terra verte, raw sienna, burnt sienna, Prussian blue, zinc white) if you wish, whilst you are painting. Use the flat round edge of an artist's palette knife to grind these pigments with the egg/water solution on a piece of glass, white formica or tile. Press the pigment well into the egg solution using a circular motion. Gather the paste together and grind again several times until it is well saturated and no longer gritty.

The Coptic icon painter, Dr. Isaac Fanous, who works on very large scale mural icons, uses a mixture of one volume of egg yolk to six of vinegar to mix his pigments, adding water to this to extend the colours whilst painting.

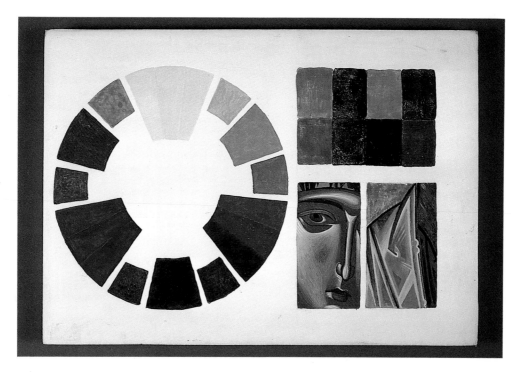

Colour circle and colour exercises on a sample panel.

Colour circle and colour exercises

The colour circle consists of the pure colours of the rainbow, with all their infinite gradations, joined into a circle. If you are bewildered by the large range of pigments available, remember that there are only three primary colours: red, blue and yellow. All colour harmony in painting is based on the inter-relation of these three. These colours each have a warm and a cold side. They are listed here from warm to cold.

Red: vermilion, cadmium red, rose madder genuine (or carmine).

Blue: ultramarine blue, cobalt blue, Prussian blue plus zinc white.

Yellow: cadmium yellow, cadmium yellow plus cadmium lemon, cadmium lemon (all with zinc white added).

Make a colour circle on your sample panel (see above), painting three gradations (warm, middle and cold) from red, blue and yellow.

The colours between the three primaries in the circle are called secondary colours, i.e. orange, purple and green. These are obtained by mixing the primaries nearest to them in the circle. The colours between the primary and secondary are tertiary colours, i.e. yellow-orange, red-orange, red-purple, blue-purple, blue-green and yellow-green.

Colours which are diametrically opposite in the colour circle are called complementary colours and form harmonious pairs. If complementary colours are mixed they will neutralize each other giving interesting greys, in some cases similar to earth colours (i.e. yellow ochre, raw sienna, burnt sienna, burnt umber, caput mortum, terra verte, etc.). When the complementaries are completely neutralized, some interesting blacks can be obtained. It is very important to be aware of this and to experiment on your sample panel.

The temperature "poles" of the colour circle are red-orange, the hottest, and blue-green, the coldest. The half-way colours, middle yellow and middle purple, do not have any temperature at all. They are in fact the "tonal" poles, the lightest and darkest colours.

It is a good idea to start compiling an extensive colour chart of interesting mixtures covering your colour range. Play with colours on a sample panel, using egg tempera and pigment. Practise the methods described: "petit lac", direct painting, hatching and cross-hatching, glazing and line painting. Do some colour-matching exercises in adjoining squares (see above), for example the mixtures described on pages 31 and 39. Attempt to copy two details from the icons on pages 16 and 29. These are useful exercises before embarking on your first complete icon.

Colours in icons have a symbolic or spiritual dimension, acting as attributes to the sacred or holy. According to liturgical tradition, certain colours are used for the priests' garments on certain feast days. The saints are traditionally dressed in specific colours. The student needs to develop a feeling for the spiritual harmony of colours. Looking at original icons rather than reproductions would be a great help.

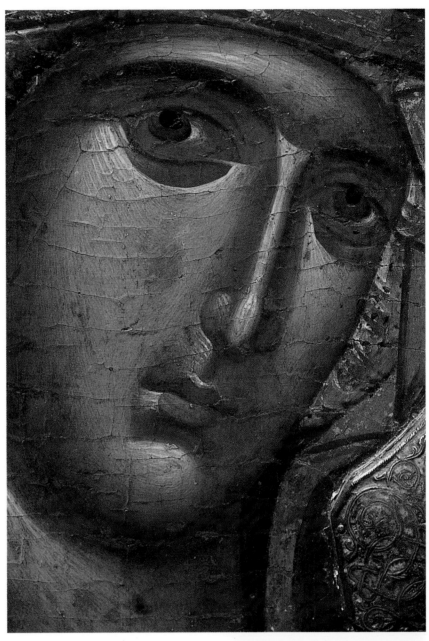

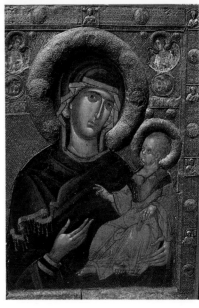

The Virgin Hodigitria and a detail. Byzantine, early fourteenth century, Icon Gallery, Ohrid, Yugoslavia. Double-faced processional icon with the Annunciation on the reverse (see page 1) and silver plaques on the background, 94.5 × 80.3cm (37¼ × 31⅝in). A detail of this icon can be seen above.

Painting the icon of the Virgin "Hodigitria" and Child

There are many different versions of the icon of the Mother and Child. In Byzantine art these can be traced back to three main models or prototypes. The first is the Virgin of the Sign (see page 9). This shows the gesture of "Orans", with the mother's hands raised as if in solemn prayer. The child is placed in the centre, within a large round medallion over the Mother's breast. A proto-version of this can be traced back to an early fourth century wall painting in the catacombs in Rome. The second prototype is the Virgin of Vladimir, known in Greece as *Eleousa* (merciful or loving kindness). This icon comes from eleventh century Constantinople and is now in the Tretjakow Gallery in Moscow. The mystical expression in the eyes of the Virgin has a sadness, as if foreseeing the Passion of her Son. The two figures embrace tenderly. This gesture (see page 51) has many variations, including the Virgin of the Passion, or Perpetual Succour (see page 3) based on a Cretan-Sienese prototype now in the Redemptorist Monastery in Rome. The third model or prototype is the Virgin *Hodigitria*, which means "the one who shows the way". As the *Theotokos*, or Mother of God, she points to the Christ child with her right hand, whilst holding him with her left. The origins of this icon go back to the fifth century. With its solemn majesty, it became the Byzantine icon par excellence in Constantinople from the ninth century onwards (see page 29, thirteenth century and variation see pages 36 and 73, fourteenth century).

You are now ready to paint your first icon in stages. The prototype or model we have chosen is the Virgin *Hodigitria* painted in the fourteenth century by a Greek artist and now in the National Museum in Belgrade. In this icon the Virgin presents the Divine Child to the world. She is pointing the way to salvation. The Child wears Greek garments and holds a scroll or "rotulus" in his left hand, whilst blessing with his right. As certain areas of the prototype which was used as a model are damaged, these have been reconstructed from other icons (e.g. the face of the Child from a fourteenth century icon of the *Hodigitria* in the church of the Eisodia at Niochori, Rhodes).

The four painting stages

As described on page 26, the Byzantine egg tempera painting technique follows a special method, building up colours in layers from cooler and darker (or medium) tones, to warmer and lighter tones. Now that you have prepared your gessoed panel, traced and incised the drawing and either gilded or painted the background, you are ready to follow the four stages of painting the icon of the *Hodigitria* (and later the icon of Christ, see page 38).

In our reproductions of the stages, the background of the icon was "water-gilded" as opposed to oil-gilded or painted, see pages 44–49. The four stages may be summarized as follows:

1. Painting the background colours.
2. Re-instating the drawing by painting the incised lines.
3. First layer of lights.
4. Letters, halos and gold lines, final build-up of layers of light and slight deepening of shadow areas, reinforcement of lines, final details and highlights.

At each stage the colour mixtures used are given. However, the proportion of the colours in these mixtures is left to the individual's own feeling for colour. For that matter, the mixtures themselves should not be considered as standard formulas. Other artists may well use different mixtures. Use the instructions given here as a guide.

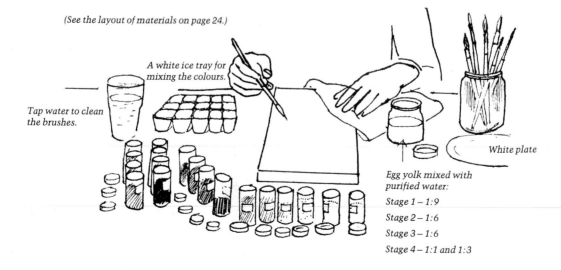

(See the layout of materials on page 24.)

A white ice tray for mixing the colours.

Tap water to clean the brushes.

White plate

Egg yolk mixed with purified water:

Stage 1 – 1:9

Stage 2 – 1:6

Stage 3 – 1:6

Stage 4 – 1:1 and 1:3

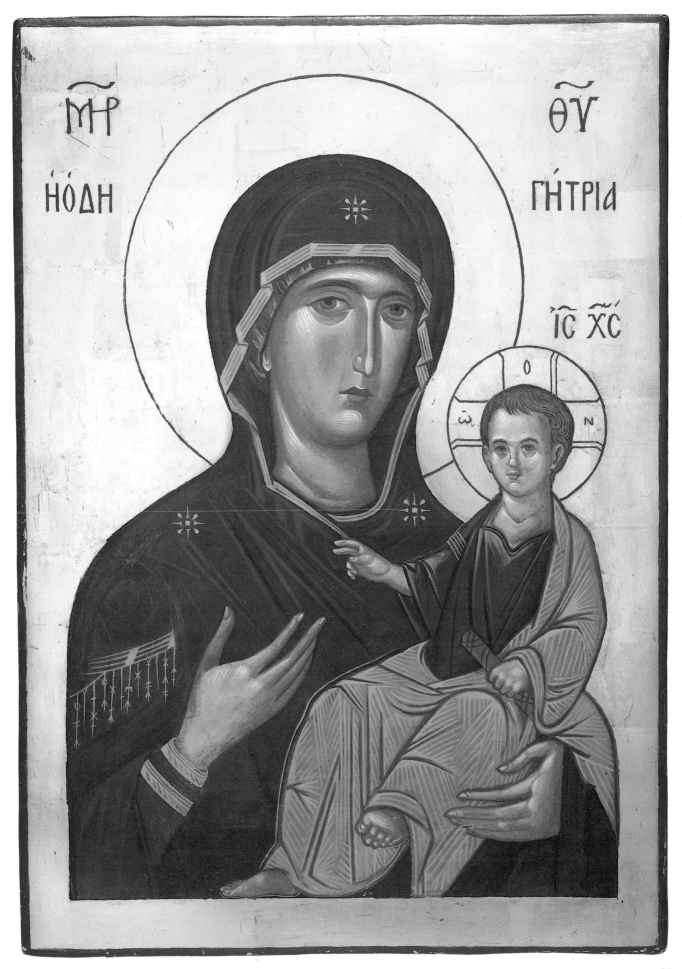

ΜΡ ΘΥ
Ὁ ΟΔΗ ΓΗΤΡΙΑ
ΙC ΧC

35

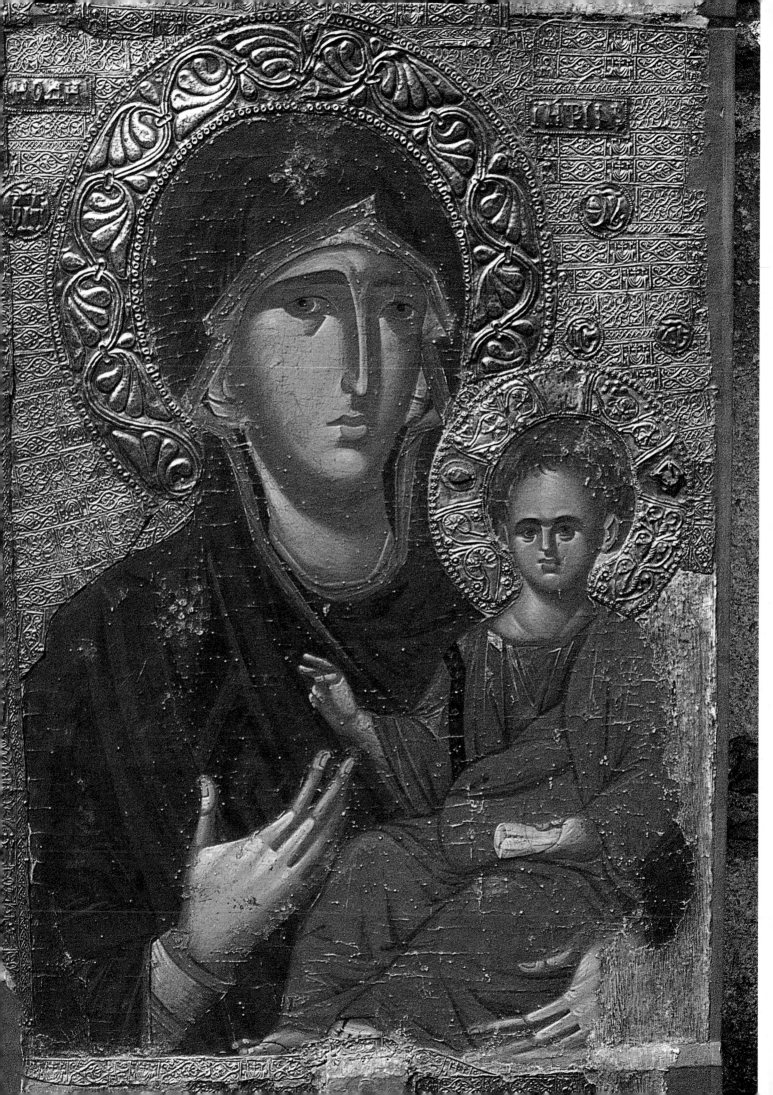

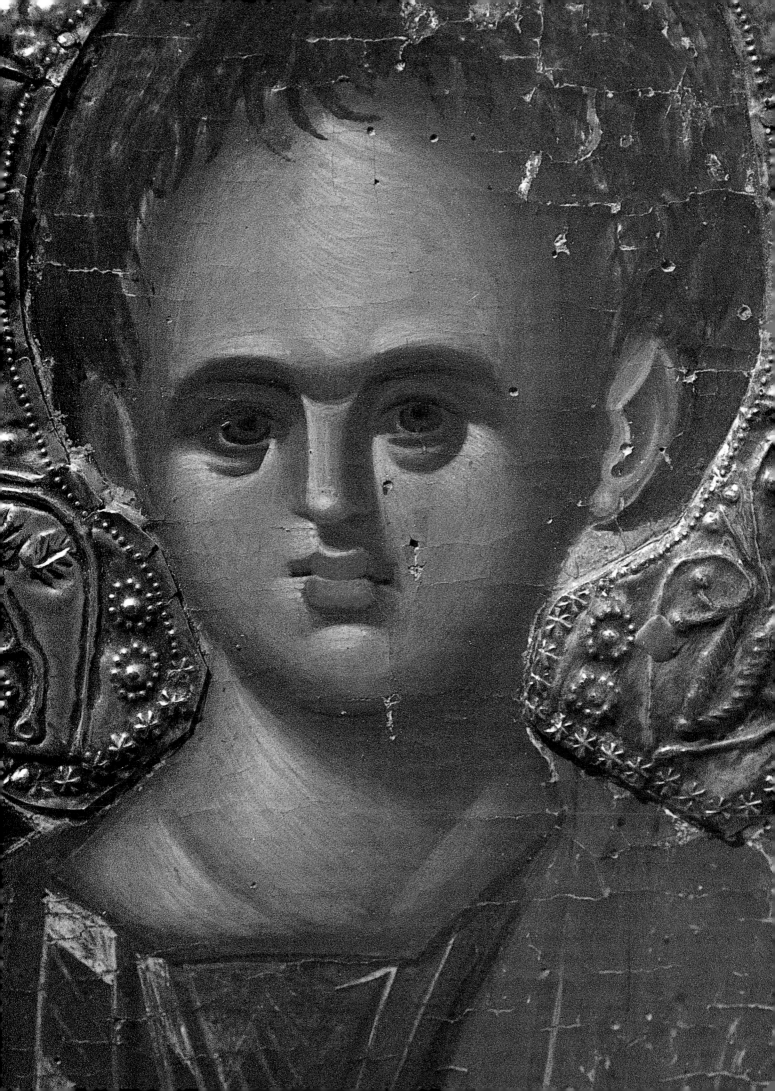

Painting the icon of Christ Pantocrator

The first images of Christ date from the third century and were found in the catacombs in Rome. Fifth century mosaics at Ravenna depict him as a beardless Apollo-like youth, although some late fourth century mosaics in Santa Pudenziana and San Prassede in Rome already show him with a beard. From the sixth century onwards he is always shown bearded and with the same features, as the majestic and solemn *Pantocrator* (the Almighty). He wears Greek clothing and holds a jewelled book, either open or closed, against his chest, whilst blessing with his right hand.

Perhaps the earliest surviving prototype of an icon of Christ Pantocrator on a panel is the sixth century icon in the monastery of Saint Catherine on Mount Sinai. This was made using the encaustic technique (with hot wax), like the Graeco-Roman portraits found at Fayoum in Egypt.

Icons painted on panel in egg tempera are rare before the twelfth and thirteenth centuries. In the prototypes of Christ Pantocrator from Constantinople, the only variations are in the positioning of the right hand and the hair behind the left or right shoulder. The hand can be moving outwards in a powerful gesture (which fits well into the round shape of domes and apses), turned inwards as if blessing the holy book, or (most frequently) centrally placed, blessing the onlooker.

The icon we have chosen for you to paint is based on a fourteenth century prototype in the Chilandary monastery on Mount Athos. The fingers of Christ's hand, whilst blessing, seem also to form the shapes of the letters of his anagram (see the finished icon on page 42).

Follow the four stages for painting the icon of the Virgin and Child, already described on pages 30–35, referring to the illustration of Christ Pantocrator on the following pages. Additional information is given as required.

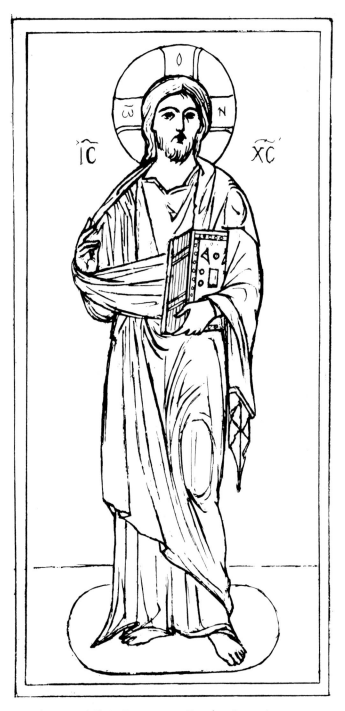

Line drawing of Christ Pantocrator. Based on Byzantine prototypes (mainly the Christ in the Diesis of an ivory mid-tenth century triptych from Constantinople).

38

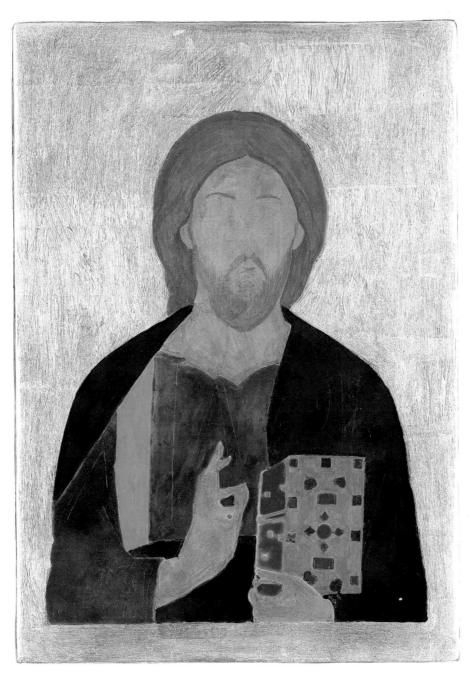

Stage one

Stage one

Paint the background of the figure using the "petit lac" method.

Skin and base colour for the hair (painted together): yellow ochre, raw sienna, terra verte, ivory black, raw umber, zinc white and some burnt umber. *Hair*: glaze over the base colour with the same colours, plus burnt umber and raw umber. *Blue robe*: (Greek *himation*): Prussian blue, terra verte, viridian, ultramarine blue and a touch of red ochre and indigo. *Red tunic*: madder deep, terra verte, touch of ultramarine blue, caput mortum violet and burnt sienna. *Pages of the book (background colour) and red jewels*: cadmium red and cadmium yellow middle. (Blue jewels same as robe.) *Golden band in tunic and book cover (background)*: two thin layers of yellow ochre, zinc white, raw sienna with a touch of cadmium orange, raw umber and burnt sienna.

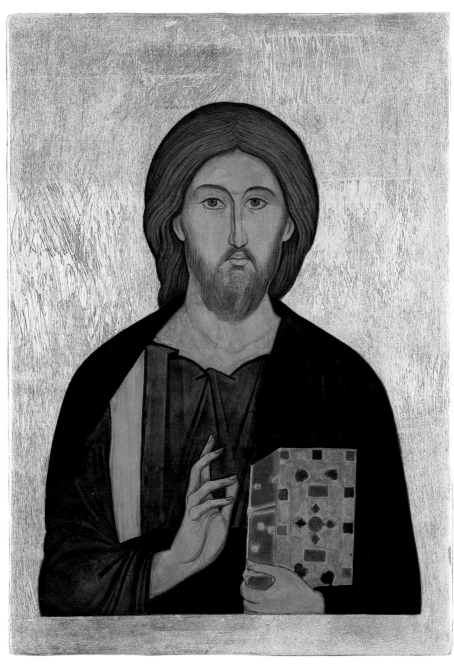

Stage two

Stage two

Reinstate the drawing with lines of the same colour, but darker, and paint in the features.
Hair line: burnt umber and terra verte for shading; burnt umber and black for dark lines. *Dark line in robe*: ivory black, viridian, burnt umber. *Tunic*: madder deep, with some ultramarine blue and burnt sienna.

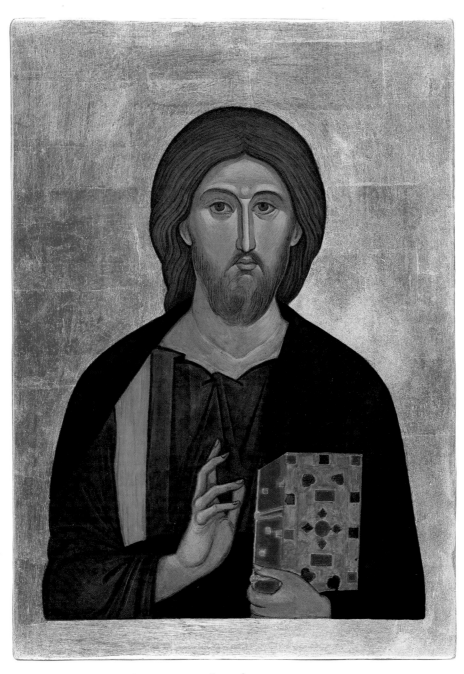

Stage three

Stage three

The first layer of lights is applied in two coats.
Skin – first coat: yellow ochre, raw sienna, zinc white and a little burnt umber. *Second coat*: raw sienna, titanium white and a little red ochre and burnt sienna. *Tunic*: madder deep, terra verte, zinc white and a little ultramarine blue and burnt sienna. *Robe*: viridian with some zinc and titanium white, terra verte, raw umber and cobalt blue. *Hair*: colour as before (see stage one) with some burnt sienna and a touch of titanium white.

When this stage has been completed, apply a nourishing layer.

Stage four – finishing the icon

Apart from the word Pantocrator, (see page 75) the lettering is the same as for the Christ Child (on page 35). Paint the gold pattern on the tunic band and on the book cover.
Red jewels on the book cover: rose madder. *Pages of the book*: same as first stage plus titanium white, with lines fading. *White circles on book cover*: titanium white with a touch of raw sienna and yellow ochre. *Robe: light lines*: viridian, burnt umber and azure blue. *Tunic*: same as background colour with rose madder and a little titanium white. *Line between the lips*: madder deep and burnt sienna.

Do not be discouraged if you cannot portray the divine/human nature of Christ with the skill of the great Byzantine artists.

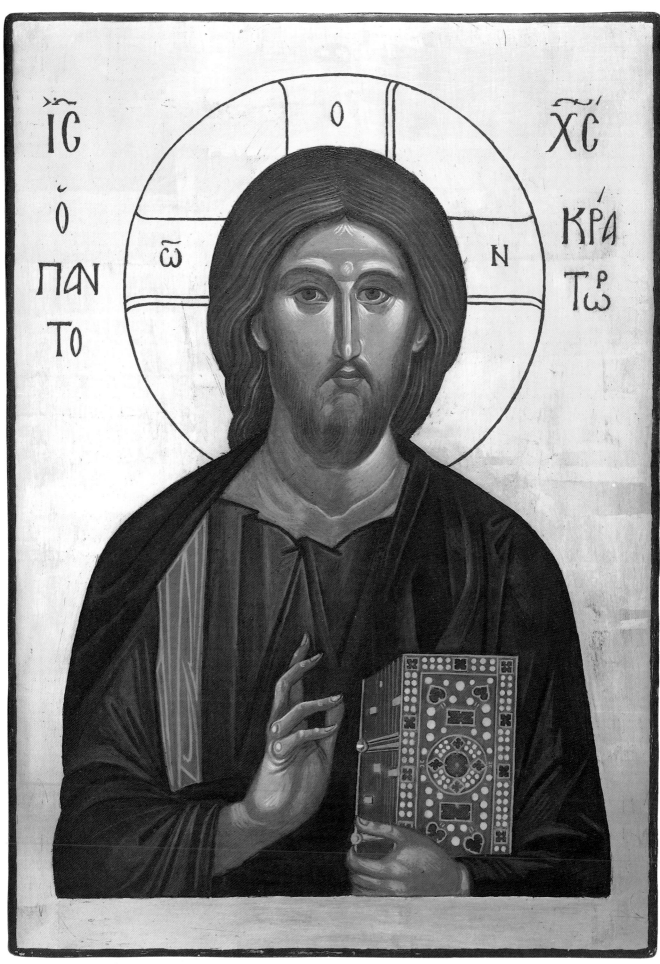

42

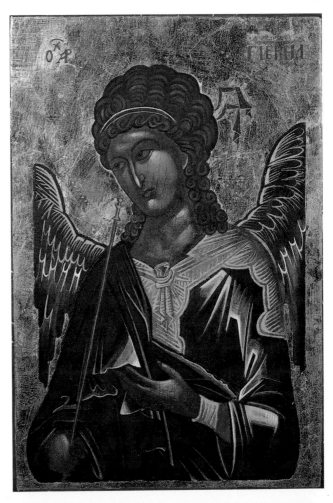

These are three examples of half-length figure icons showing the type of subject you could choose for your next icon:

Above left: *St John the Baptist. Based on a Byzantine icon from Constantinople, in the British Museum, London. 21.5 × 15.5cm (8⅜ × 6⅛in). Original 25.1 × 20.2cm (9⅞ × 8in).*

Above right: *The Archangel Gabriel. Based on a Greek icon (circa 1360) at the Chilandari Monastery, Mount Athos. 23.5 × 16.5cm (9¼ × 6½in). Original 100 × 64cm (39⅜ × 25¼in).*

Below right: *The Archangel Gabriel. Based on a sixteenth century Cypro-Cretan icon from the iconostatis in the Monastery of Ayios Neophytos, Cyprus. 42.5 × 31cm (16¾ × 12¼in). Original 83 × 69.5cm (32¾ × 27⅜in).*

Opposite: *Stage four – the finished icon. 38 × 27cm (15 × 10¾in).*

Water gilding

A combination of water gilding (using gold or silver leaf over a different coloured bole base) and oil gilding (using different shades of a background colour), can give interesting decorative effects to the background of an icon. Some artists water gild the halos and paint the background. Oil gilding, described on page 22, is the simpler method of gilding. Water gilding is more time consuming and expensive but gives by far the most impressive result. Indeed it can be very beautiful, for the gold leaf can be burnished to reflect the light, giving the appearance of solid gold. The disadvantage of water gilding is the initial expense of investing in specialized equipment. It also requires preparation, patience and skill. However, students thoroughly enjoy this method of gilding and are amazed by the results, which undoubtedly enhance a good painting.

Applying the bole

Bole is a very smooth and soft clay available in paste or in dry form in cones. Together with the underlying gesso it acts as a "cushion" on which the gold leaf can be burnished. The final colour of the burnished gold is affected by the colour of the bole.

Bole is available in yellow (similar to yellow ochre), terracotta, red brown, black, blue, grey and white. A small amount of gilder's whiting, graphite powder and a touch of cadmium red can be added to the bole to improve the colour and burnishing properties.

Materials

Yellow bole (of a yellow ochre colour) plus small amounts of gilder's whiting, graphite powder and cadmium red pigment if required; a lukewarm gelatine/water solution made with one packet of gelatine, (see page 19, but here the concentration is 1:23); a white soup plate and tablespoon; a "mop" (dome-shaped) squirrel or pony-hair brush (or a large round sable or nylon brush), and an assortment of round and flat (sable or nylon) brushes; a "stipple" or "stencilling" hog-hair brush; the finest (0000) wire wool, or fine wet-and-dry sandpaper nos. 400, 600, 800, 1200 (available from hardware/tool shops); a soft piece of cotton cloth or velvet; purified water and a few drops of methylated spirits.

Preparation and application of the bole

Pour lukewarm gelatine/water solution (1:23) into a white soup plate. Add the bole (and the optional ingredients mentioned above) and mix with a tablespoon, brush, or your fingers to a very fluid paint. If the bole is in a wet (paste) form it can be added directly to the gelatine solution. If it is in a dry (cone) form, it must first be pounded to a powder and left to soak in purified (or boiled) water to become paste-like, before being added to the gelatine solution. (Some gilders prefer to filter the bole paint solution through a gauze to remove any possible grit or deposit.)

Paint this bole solution very smoothly and thinly over the background area to be gilded. Use the "mop" brush (or a large round sable or nylon brush), making single strokes in one direction. Use smaller brushes when necessary to follow precisely the contours of the image.

The first coat will seem to be very transparent. When it is dry, apply another coat in the opposite direction and so on, up to five or more coats. As soon as this is dry, the boled surface can be made absolutely smooth by rubbing, first with a stipple brush and then with the finest 0000 wire wool, or with wet-and-dry sandpaper used dry. (This type of sandpaper is never thrown away, but washed and kept for further work.)

Finally, polish the bole by rubbing it vigorously with a soft piece of cotton cloth or velvet. The boled surface must be immaculately smooth with no tiny scratches or faults, as these will show through the gold. Check this by going over the surface with a natural sponge, or soft cotton cloth moistened with purified water and a few drops of methylated spirits. If the surface is not perfect, apply another layer of bole and polish again.

Now put the panel aside, covering it with a cloth to protect it from dust and prepare your materials for the application of the gold leaf. In future works you may wish to experiment with other colours of bole or bole mixtures, or with terra verte pigment, if this would enhance the colour scheme of your icon.

Applying gold leaf

Specialised equipment is required for the application of gold leaf. This is described in detail as follows.

Gilder's cushion

Ready-made gilders' cushions consist of a piece of suede fixed over a 24 × 15cm (9 × 6in) block of wood, with two layers of cottonwool padding beneath the suede to give a slight spring. A piece of parchment paper, or card, is attached around one end as a draught protector, to prevent the gold leaf from blowing away. Two leather finger straps at the back enable experienced gilders to hold the cushion in one hand. However, we will be using it on the work surface. A cushion this size only holds two leaves of gold, and you could make your own, as explained above, four times as large, with a free-standing card draught excluder. The textured surface of the suede must be kept very clean; it is traditionally dusted over with bole scraped from the cone with a blade and rubbed in with the fingers.

Loose gold leaf

This is real gold, which being very malleable is manufactured by hammering it between pieces of leather to form leaves of an extraordinary thinness. It is available in a variety of shades or colours from white and lemon coloured to more orange and reddish

colours, depending on the carat value and the copper or silver alloy content. These colours serve many different decorative purposes, from the gilding of furniture and picture frames to picture restoration and illumination. Normally only the 23¼ carat gold is used, which is a "classic" shade suitable for icons. The final colour of the gold when burnished is affected by the colour of the bole underneath. It is advisable to use a bole colour close in tonal value and colour to the gold itself in order to harmonize with it.

It is advisable to compare prices at different shops or manufacturers before purchasing your gold leaf. The books contain 25 sheets, each leaf being 8 × 8cm (3¼ × 3¼in).

Gilder's knife

The gold leaf is cut to shape with a gilder's knife. This has a 15cm (6in) long stainless steel blade, which must be kept free from grease or damage, for if the blade is slightly dented it will tear the gold instead of cutting it. After using two or three books of gold leaf, the knife will need sharpening on a very fine whetstone with lubricating oil. When the blade has become very sharp it must be slightly blunted again (by moving it vertically across the stone), otherwise it will cut through the suede on the gilder's cushion. Alternatively the knife can be sharpened with fine wet-and-dry paper.

Since the gold must not stick to the knife, both sides of the blade have to be rubbed across the cushion immediately before starting, to remove any possible grease or static.

Gilder's tips

Gilder's tips are used for picking up sections of gold leaf from the cushion, where they have been cut with the gilder's knife. These tips are made of squirrel hair and are available in different lengths (short, medium and long) for the different sizes of gold leaf pieces being used.

For our purposes see (the gold) through tips are used. The short-haired tip is used to pick up thin strips of gold, and the medium or long-haired tip is cut in half and used to pick up whole quarters of gold leaf. Picking up an entire leaf requires a lot of experience and a double tip. However, this is too difficult for beginners and is only required for large icons. The tips must always be kept clean and free from dust.

In order to pick up the gold better the tip must be very slightly greasy, but not visibly so, and "static". A drop of aromatic/essential oil is rubbed into the inside wrist and the hair of the tip is flapped several times over it. Alternatively the hair can be flapped on the artist's own hair, assuming it to be very slightly greasy. The flapping also produces static which helps to attract the gold leaf. After gilding several icons, the hair (on the tip) should be gently washed with liquid soap.

Agate burnishers

There are different shapes and sizes of agate burnishers for the purpose of burnishing, for example, the recesses of intricately carved frames. You will only need one or two of an appropriate shape to burnish a flat surface: one small (but not too small) and one large, or else just one of medium size instead. Keep the burnisher clean and do not drop it or let it touch a rough surface, for the finest, practically invisible scratch on it will damage the gold during burnishing.

Agate burnishers (actual size)

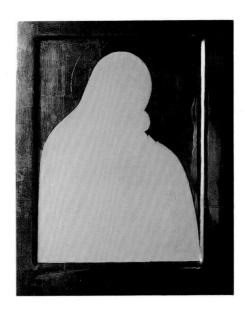

The water gilding method was used on the icon of the Virgin Eleousa which can be seen on page 51.

45

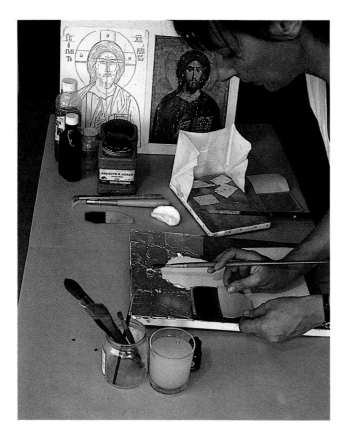

Layout of materials required for water-gilding. Laying down gold leaf with the gilder's tip.

Application

First set up all your materials ready for gilding as shown above.

Materials

A gilder's cushion; one or more books of loose gold leaf, 23¼ carat; a stainless steel gilder's knife; two gilder's tips of see-through squirrel hair, one of short hair, the other of medium or long hair – the latter to be cut in half with scissors (making three in all); a tiny bottle of aromatic oil; cottonwool; one large and one small agate burnisher, and a nylon brush.

Water, gelatine and methylated spirits solution

This dampening solution is prepared immediately before gilding. To a glass of water (preferably purified or boiled) add a small amount of methylated spirits, alcohol or methanol, and a small amount of luke-warm 1:23 gelatine solution (about 3–4 tablespoons of each – see page 19). Apply generously several times, with a very clean nylon brush, over the area to be gilded, previously prepared with the bole.

Technique

a) With your panel slightly tilted up, apply the dampening solution as described.

b) Put the book of gold leaf next to the cushion and open it at the first sheet. With a quick twist of the wrist turn the book upside down on to the cushion, to transfer the leaf. Gold has always been very elusive. The slightest movement of air will send it flying away. Therefore shut all windows and doors, keep very quiet and above all do not breathe over it!

c) You may now enjoy playing a little with the gold, manipulating it on the cushion with the gilder's knife in order to experience its fragility and to practise handling it. First rub both sides of the knife blade against the suede. The springiness of the cushion will enable you to press down on the blade, inserting the end under the gold leaf. When the blade is right under the gold leaf it can be lifted, and either turned over, or moved about the cushion (e.g. to the back to make room for another leaf).

If the leaf becomes twisted or wrinkled, press the edge of the knife along the edge of the leaf to hold it, whilst you blow gently over the centre of the leaf to send it rippling out flat again. Do not touch the gold with your finger or it will stick to your skin. Even if the leaf becomes all wrinkled and damaged it will not be wasted, for you can keep it in a white envelope for other uses (see 'Faulting' opposite and 'Fine lines in gold' on page 48). Above all, do not despair, but try again.

d) To cut the gold leaf, first rub both sides of the knife blade against the suede, then hold it directly above and very close to the gold leaf on the cushion. Bring the blade down absolutely vertically, to cut the gold leaf in half, with a slight sawing motion back and forth. Lift the knife and repeat, cutting each gold leaf sheet into quarters to gild large areas, or into three or four strips for borders. Since gilding is done from the top of the panel downwards, quarters will be required first.

e) Dampen the area of bole once more, making sure it looks wet, before applying the gold leaf.

f) Take one half of the long-haired gilder's tip; rub it against your hair or wrist as described on page 45. Hold it directly over and closely parallel to one of the gold quarters, but with a few millimeters of gold visible over the top edge of the hair. Lower the tip and it will pick up the gold from the cushion. Carefully take the gold-laden tip to the wet bole at the top left-hand corner of your panel, keeping it parallel. As soon as you are close to the wet surface (without actually touching it) it will pick up the gold leaf. This is a nerve-racking operation at first, until you realize a child could do it. Therefore, without wasting time in surprise and admiration, pick up another quarter in the same way and (making sure the bole is still wet) place it to overlap the edge of the first piece by two or three millimetres (a fraction of an inch). Position the

remaining two quarters, and then cut another leaf. When the background is nearly filled in cut suitable shapes (such as triangles or narrow strips) to surround the figure, with a slight overlap.

If the bole becomes dry it must be dampened again, without touching the gold already applied, as this would leave a wet mark which could not be burnished. Bring the wet brush close to the edge of the gold however, so that the liquid will be drawn underneath by osmosis.

The leaves are not always absolutely flat immediately on application, particularly at the overlaps. The moisture underneath will pull them flat after a while, but in some areas you can help by pressing slightly with a small piece of cottonwool.

g) The gilding can be completed by simply keeping the bole wet and applying the gold leaf in quarter squares, lengths, or any other shape or size required, taken from two leaves cut up ready on the cushion. As the pieces must all overlap, there will be loose wisps or "skewings" of gold at certain seams or at the edges of the panel. These can be removed when the gilding is completed. After about half an hour, gently go over the surface with a piece of cottonwool to collect the loose gold in an envelope for future use.

At this point you may realize, with quite unnecessary horror, that there are small gaps where the gold leaf has "missed". This is not a disaster, for although it would have been better not to have these gaps, they can be patched up later after burnishing. They can also be left as they are (see page 43 – St John the Baptist); this is why a bole colour of the same tonal value as the gold is used (not darker) so that any gaps will not show too much.

If the gold leaf has slightly overlapped the contours of the actual image, it can be removed later by: rubbing the overlap with a cottonwool bud; rubbing it with the point of a soft cloth impregnated with water and a drop of methylated spirits; rubbing with wire wool or scraping gently with a blade.

Burnishing the gold with the agate

Burnishing must be carried out two or three hours after gilding. If it is left until the following day, the bole underneath the gold will have become too hard and you will not get the best results.

Now the moment has arrived when all your efforts will be rewarded. Start burnishing systematically with the small agate, first one way and then at two slightly different angles to this direction, in a closely-knit pattern. For the best results these directions should relate to the way the icon will be illuminated when it is finished. The light could come from above, from the side, or from underneath (e.g. from candles) and the panel should be in the relevant light direction during burnishing. If the final light source is unknown, keep illuminating the gold from different angles. (To keep the agate warm rub it intermittently against the side of your nose!)

At first do not press hard with the burnisher, but gradually increase the pressure. The burnishing directions should be very close to each other to avoid leaving pressure marks. Do not jump from one part to another, but gradually extend the burnished area until all the gold has been covered. Finish with heavy pressure using the larger burnisher. The more you burnish, and the greater the pressure, the more the gold will shine. You may now sit back and admire the result.

Note

Burnishing must be systematic and therefore requires patience, as it can take from half an hour to an hour or more. Although the burnishing marks and joins of the gold leaf will not show under normal light conditions, they may show if the icon is illuminated by indirect light, for example when being photographed.

Patching up or "faulting" and "distressing" the gold

If, unfortunately, you have missed gilding in several places so that the bole shows through, this can be corrected after burnishing.

Holding the gilder's tip with your left hand, pick up a section of the gold leaf, larger than the faulty area. With your right hand use a small sable brush to dampen the area slightly with the gilding solution used before (or alternatively breathe on the area and apply the gold). Apply the gold immediately. After five or ten minutes this area can be burnished also. Very small defects could be touched up with shell gold, or with a liquid gold solution.

When you have finished burnishing the icon, you will find that the gold is too shiny, and stands out too much from the image. To reduce its shine, coat the gold with "glair" (see 'Varnishing the icon' on page 50), or with one or two very thin layers of a solution of gelatine, or rabbit skin glue granules and water, 1:18 (see page 19). This gives the gold a silky look more in harmony with the painted image. If silver is used instead of gold, a thin coat of clear lacquer will prevent it from tarnishing.

Some artists prefer to "distress" the gold before the letters are painted. The purpose of this is to thin down the gold to enable the bole to show through slightly. One method is to rub the surface of the gold with either very fine 000 wire wool, or with pumice powder or rottenstone using a piece of cottonwool. Alternatively, a liquid clear toner, such as a special alcohol based shellac or lacquer will tone down the gold. Distressing the gold in this way can give an interesting antique, or decorative, effect (for instance by distressing the background but not the halo). However, it has the disadvantage of showing the "faulting" of the inexperienced gilder. I would recommend that you therefore experiment and make a few tests before deciding to use this technique.

Double gilding

Some artists prefer to "double gild". After the first layer of gold is applied, another layer is put on top. This time the first layer of unburnished or burnished gold is dampened only slightly, section by section, with the gelatine solution, using a flat clean brush. The whole area of gold is then burnished again.

This rather expensive operation is advisable as an alternative to "faulting" bit by bit, if the first layer has too many imperfections.

Painting lettering, or an image, on burnished gold

When the painting is quite finished, a tracing of the letters is placed over the icon. This is described on page 34.

In the case of a very small icon only a few inches across, or a tiny figure, the image is painted entirely over the gold, following the same process as described on page 34 (see the angels on page 3).

Indenting patterns on gold

Decorative patterns in the halo or background must be carefully planned and drawn on tracing paper. They are then punched through the tracing paper using a small hammer and blunt-point tools, such as tiny bol metal burnishers. These are used in etching and are available from art material suppliers. Metal tools for punching decorations in leather are too sharp and will cut the gold. Some artists make their own tools for this out of metal objects such as nails, etc.

If oil gilding has been used, the pattern can be traced on to the gold through tracing paper with a fine ball-point pen, while the varnish under the gold is still slightly soft, giving a fine indentation.

If you wish to pattern the gold, make sure the decoration is in keeping with the style. Do some research by visiting museums and looking at reproductions.

Fine lines in gold over a painted image

These are achieved either by:

a) Scratching through the colour painted over gold, using a very fine pointed piece of wood, e.g. the sharpened handle of a small paint brush (see Christ's garments on page 56). This technique is called "sgraffito".

b) Using transfer gold over lines painted with Japan gold size.

c) By painting the lines with "shell gold".

If transfer gold over Japan size is used (see page 23), the painted surface to receive the lines must first be dusted over with talcum powder to remove any possible grease, and then sealed with a thin coat of weak gelatine/glue solution and left to dry.

The most effective way of painting gold lines however is by using shell gold. This is a minute tablet of concentrated real powdered gold, held together with a drop of gum arabic and sold in a tiny dish (formerly in a little shell, hence the name). The lines are painted in first with egg tempera and pigments such as yellow ochre, using a finely pointed sable brush. This colour is used as a base, and once it is dry, the shell gold is painted over it. Water is added drop by drop to the edge of the small tablet of shell gold to dilute the gold.

You can prepare your own shell gold. Grind or mix the scraps of gold left over from gilding with a small amount of honey in a small pestle and mortar. Mix in some hot water. The gold will form a deposit at the bottom and the excess water can be poured off. The gold paste deposit is left to dry in a tiny dish with a drop of very weak gum arabic solution.

Different types of gold colour substitutes are available, e.g. a mixture of bronze powder and cellulose lacquer, acrylic gold paint, etc.

Opposite: The Virgin. Based on a sixteenth century Cretan icon (decoration on halo and borders added later). 31.75 × 23.8cm (12½ × 9⅜in). Original 32.4 × 26.6cm (12¾ × 10½in).

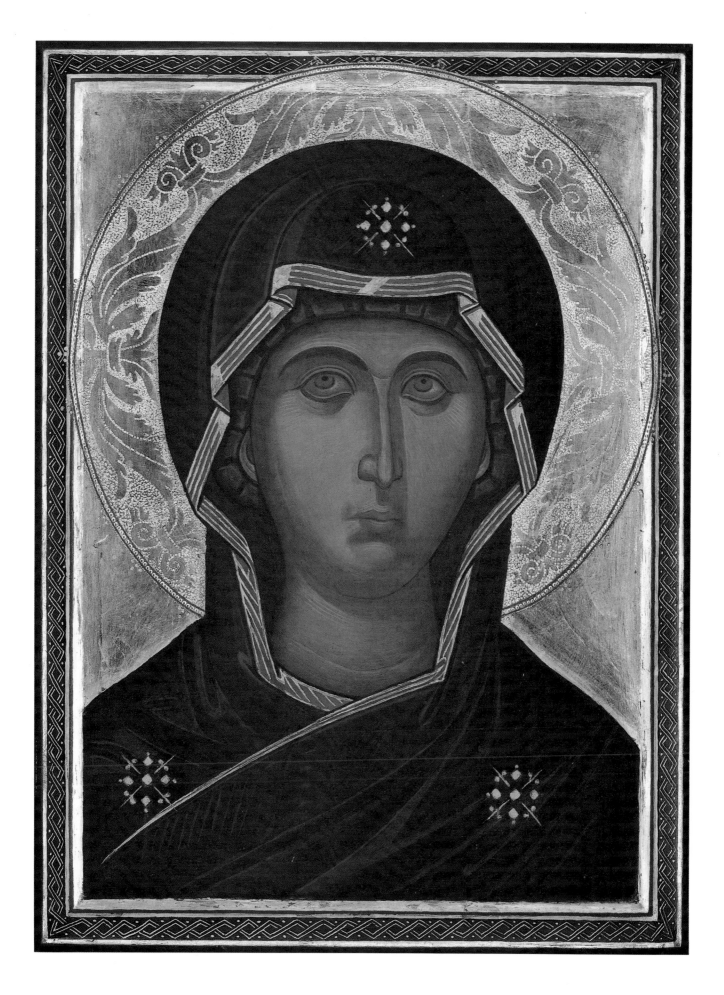

49

Varnishing and mounting the icon

A newly painted icon should not be varnished for a long time, at least for a few months or more, since the egg painting medium takes a long time to harden thoroughly. (After one or two years an egg tempera painting becomes so hard that it can even be burnished, providing it is very smooth.) However, the painted area can be sealed within a few weeks with one thin coat of half "glair" and half purified water.

Glair is white of egg, beaten for a long time to a froth, then left to stand overnight. The following day the surface crust is thrown away; the liquid underneath is the glair. An alternative to this would be a thin coating of 1:15 rabbit skin glue/water solution.

First coats and finishes

After a few months the icon can be varnished. For a preliminary coat, two light applications of "artists' picture varnish" (available in aerosol) are sprayed over the entire icon, allowing one hour to dry between each coat. Alternatively, apply two thin coats of "retouching varnish" over the painted area only, using a 7.5cm (3in) wide, flat, soft brush (preferably sable). After two or three days, this operation can be repeated, this time using artists' picture varnish in spray or liquid form.

Retouching varnish and artists' picture varnish (with a gloss finish) are made of ketone resin crystals diluted in white spirit, the former being a weaker solution. The purpose of the varnish is to bring out the full colour effect in dry or sunken areas, in order to produce a uniform appearance, and to protect the paint.

For a slightly silky or semi-matt effect, apply a "matt picture varnish" made of ketone resin, white spirit and micro-crystalline wax. When bought ready-made, the matt varnish, which is not available in spray form, must be thinned down with white spirit to a liquid consistency to prevent brush marks showing (particularly over the gold). The application of the matt varnish requires skill. The presence of the wax means that the surface of the icon must be warmed (by holding it under an infra-red heater or strong bulb, in a completely dust-free atmosphere). Using the 7.4cm (3in) flat, soft brush, the varnish is applied thinly, criss-crossing the entire surface very quickly and lightly to avoid brush marks. After a few days, if a more matt effect is required, a very thin coat of ready-made micro-crystalline wax polish is applied, in a warm atmosphere, using a small piece of chamois leather. Be careful not to rub too hard or you may soften the varnish underneath. When this coat is dry the surface is gently polished with a piece of silk or very soft cloth. Some artists' matt varnishes contain fumed silica as a matting agent, instead of wax.

Cleaning the brush: the varnish is removed from the brush by dipping it in white spirit. The brush must then be kept immaculately clean, preferably by sealing in a special melinex non-stick transparent plastic.

Making your own varnish

You can make your own picture varnish and matt varnish by putting ketone resin crystals in a small stocking or gauze bag, and leaving them to dissolve overnight suspended in a closed jar of lukewarm white spirit. For the matt varnish, a small amount of melted pure beeswax, or the harder micro-crysrtalline wax, or cosmolloid 8H wax, is added. The proportion of ketone and wax in the white spirit is relatively small, to retain a very fluid consistency.

Removing the varnish

If you are not satisfied with the varnish coating because of an uneven finish, or trapped dust, or because you wish to retouch a colour, it can be removed by gently going over the surface with several pieces of cottonwool impregnated (but not dripping) with white spirit.

Alternative varnish

The icon could also be varnished with clear shellac (bleached shellac flakes diluted in methyl alcohol, methanol or methylated spirits). Unlike the previous varnishes, this cannot be removed easily. Colour retouching could be done over the top however. If shellac is used, the icon could be waxed and polished as described. The painted lines in the outer borders can be protected with a thin coating of shellac.

The back of the icon

If the back of the icon has been primed with gesso, a colour (e.g. earth brown) can be painted over it, preferably with acrylic paint or emulsion, to prevent it from getting scratched. Information about the icon is painted on in red or white with a calligraphers' brush. This could include: name of the icon, or prototype; source, style, period and location of the prototype on which the icon was based; the period in the liturgical calendar, or Feast day for which the icon was completed, dedicated or blessed; the name of the priest who blessed it with the date and church or chapel; the name of the artist or iconographer and assistant. A Greek cross is painted at the centre top. If the back is not primed with gesso and the wood is exposed, the information can be painted on and then the back varnished with, for instance, a solution of paraloid B72 resin in acetone, or with clear shellac, or with polyurethane varnish.

Mounting the icon

Icons are never framed like other pictures. An icon can stand alone without any frame, or it can be mounted for protection against a wooden panel covered with velvet (of a terra verte colour). This provides the contrasting texture of a soft background. The icon could even be inset, with its surface level with the flat, velvet-covered frame surrounding it.

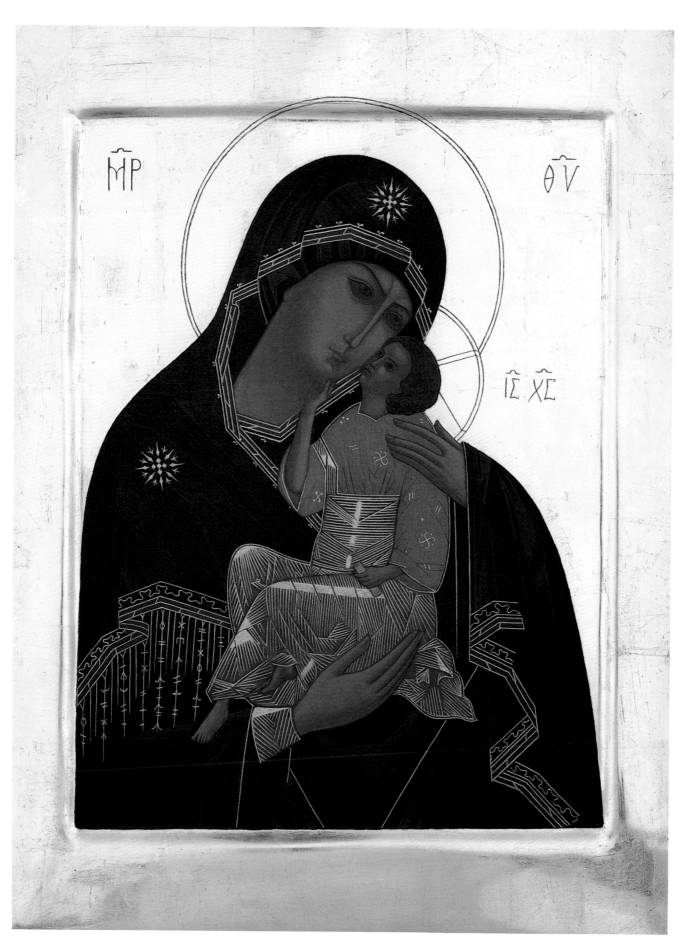

The Virgin Eleousa ("merciful or loving kindness").
Based on a Yaroslavian Russian prototype. 51 × 38cm (20 × 15in).

Drawing and painting a full-length figure

Before studying icon compositions involving several figures with both landscape and architecture, it is advisable to make a study of a full-length standing figure (e.g. Christ, the Virgin and Child, an angel or a saint).

Drawing

As before, you can either draw the figure freehand, or trace it directly from a reproduction. If you are drawing freehand you could first draw a vertical line on a piece of tracing paper placed over the reproduction. Then, to help with proportions, draw a series of horizontal lines dividing the figure into three or four. Notice the width of the body at different levels and the proportionate length of the arms and legs. Now, measure how many times the length of the head (excluding the hair) will fit into the length of the body. This proportion has varied from time to time and from school to school. For a figure of Christ the ratio is usually 1:7½ to 1:8, and for the Virgin 1:8¼ to 1:8½. Later schools, particularly the Russian school, elongate the figure to 1:9 or 1:10 to give it a more dematerialized, spiritual dimension.

To paint a single full-length figure, first make sure you have a panel of the right proportions (usually 1:2 – width:height), allowing space for the base or floor, halo, letters and borders. Consider the space around the figure by carefully studying the prototype, and take the necessary measurements before starting to draw.

Painting

Use the "petit lac" method for the skin (see page 26). The background colour for the clothing is usually direct painting (see page 26) to prevent it from looking too solid. Afterwards strengthen the clothing by painting in the dark lines of the folds, applying glazes to deepen the colours and painting in the geometric patterns of light. Be aware of the articulation points of the body underneath the clothing and define the folds carefully to avoid any resemblance to a shapeless curtain!

Continue the icon as before, consulting prototypes for the letters. If these are not clear, advice from an expert on ancient biblical Greek or a Slavonic language must be sought. On page 75 you will find the Greek texts on the icons reproduced in this book.

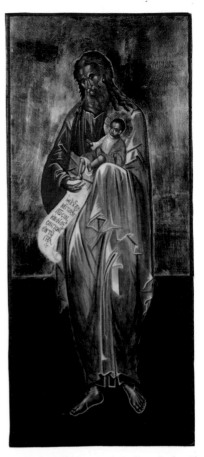

St Symeon Theodochos (Receiver of God) with the Christ Child. Based on a sixteenth century Cretan icon in the Church of St Matthew Sinaiton in Iraklion, Crete. 42.5 × 16.5cm (16¾ × 6½in). Original 99 × 32cm (39 × 12½in).

The Virgin of Katafigi (Our Lady of Refuge) and St John the Evangelist. Based on an icon by a master from Salonica (circa 1371), now at the National Art Gallery, Sophia, Bulgaria. 39 × 20cm (15⅜ × 7⅞in). Original 89 × 60cm (35 × 23⅝in).

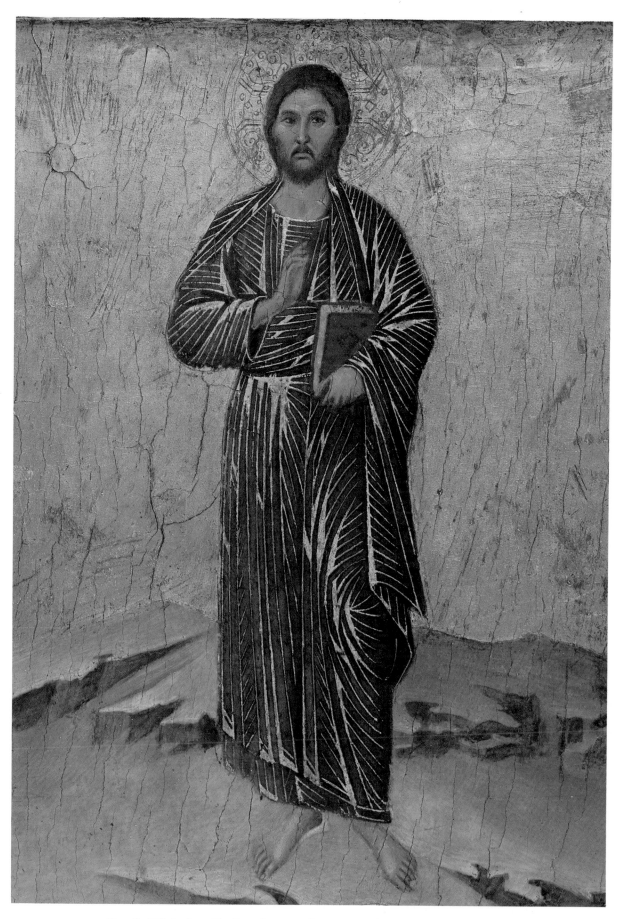

Detail of Christ from The Transfiguration *by Duccio, School of Siena, early fourteenth century. Panel from the back part of the predella of the Maestà altarpiece, now at the National Gallery, London.*

Perspective in icons – buildings, furnishings and figures

Space

Perspective in icons is not bound by the rational conventions of perspective formulated by Leonardo da Vinci during the Italian High Renaissance. This method of representing linear perspective was to dominate Western art until it was challenged in the twentieth century by the Cubists, who interpreted reality by juxtaposing several viewpoints on a single canvas.

Icons freely incorporate several viewpoints, challenging terrestrial laws by elevating perspective to a level higher than the third dimension. They are not subject to earthly laws of time, space and gravity. The icon shows a cosmic version of events, seen in eternity and is not, therefore, subject to the transience of time. Space is conceived as a series of metaphoric levels into the world of the spirit.

Different perspectives

A single composition can combine a variety of perspectives affecting its different elements (e.g. parts of buildings, furniture or furnishings). These can be:

linear *axonometric*

1) A linear converging perspective with several vanishing points.

2) Axonometric projection, where receding lines remain parallel with no horizon and receding objects do not diminish in scale.

converging *curved*

3) Inverse perspective, where the vanishing point is the spectator. (This is the most frequently used.)

4) A curved horizon perspective, as in a concave mirror. The spirit endows matter with a new dimension and buildings and objects bend towards the holy figure (e.g. the city walls on page 59 and the table on page 77). This represents a cosmic vision, where the universe is curved like a sphere (see page 17), the centre of which is Christ (see page 56).

5) A view from above, as of God looking down; or from below as of the spectator looking heavenward; or a view from ground level as if the spectator were prostrate at the feet of the saint.

Buildings and furnishings

When drawing buildings in a composition, observe the use of these different perspectives, as seen for example opposite and on pages 6 and 66. The base of the Virgin's stool is at eye level in the line drawing opposite, while the bases of the column and the parapet have two different axonometric projections.

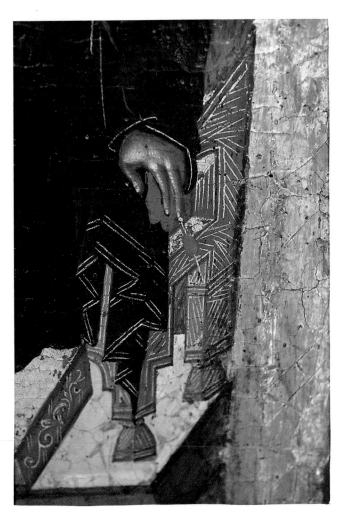

Detail of the Virgin's stool, from the icon of the Annunciation on page 1.

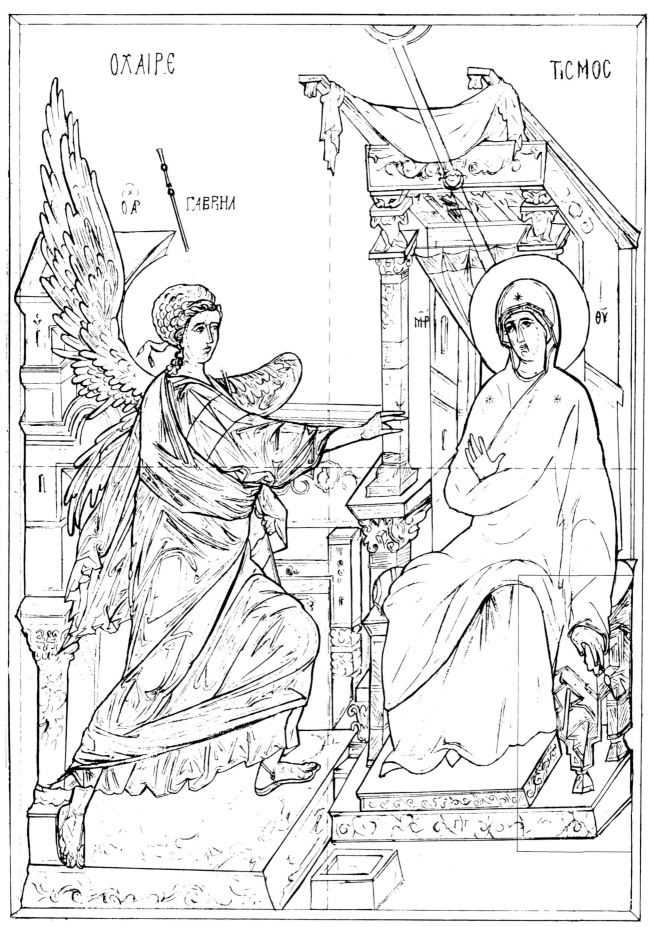

OXAIPЄ ΓΑΒΡΗΛ ΤΙCΜΟC

Line drawing for the icon of the Annunciation on the front cover, with a section of the original icon reproduced on the opposite page.

The architecture in the icon on page 6 shows a combination of these different perspectives.

Buildings in Byzantine icons are colourful free interpretations, with elements taken from Greek architecture and late antique ornament. They are painted as "backdrop" scenery and even if the scene supposedly takes place in an interior, the figures are shown in front of the building. To suggest the idea of enclosure, or an interior, a red cloth is painted hanging across the buildings (see page 1 and front cover). This is the veil which concealed the Holy of Holies in the Old Testament and which is now opened to reveal the Christian message to the world.

Architecture is not painted with "petit lac", but with flat brushes to obtain a very flat even layer of colour which is not too heavy. Take care to paint vertical lines straight and to notice the lines which are not quite vertical or horizontal. The parts of the buildings in shadow are not subject to gradations of shade in a naturalistic way, but are painted as flat colour. Pay attention to the decorative elements on the buildings.

The spiritual perspective of the head

The intriguing mystical expression of some faces invites speculation on the possible use of several perspectives simultaneously to render the features. When the head is in three-quarter view for example, the nose seems to be in profile, while the ear is seen in full. The nearside eye seems to be looking upwards, while the other is looking at us, although the amount of white underneath implies it is looking upwards. The mouth is almost frontal, while the chin is seen slightly from below. (This description may seem exaggerated, but it may help when trying to capture the expression in the prototype of the Virgin.)

These subtle changes of perspective in the face are echoed in the body. All the shapes in the features are thus related to the shapes in the figure. The head is not meant to be viewed in isolation and when the icon is seen as a whole, particularly from a distance, these apparent distortions merge in total harmony. The illumination of the face radiates from within. This cannot be rendered in a naturalistic manner, but must be carefully studied from the prototypes.

Christ in Glory. An example of an eclectic icon, showing a mixture of styles. Based mainly on a prototype by Andrea Rublev (Tretyakov Gallery, Moscow) but with a Byzantine head of Christ and hand blessing, and a text in Hebrew from John 11:25–26 which translates 'I am the resurrection. If anyone believes in me, even though he dies, he will live, and whoever lives and believes in me will never die'. 51 × 38.75cm (20 × 15¼in). Original 18 × 16cm (7⅛ × 6¼in).

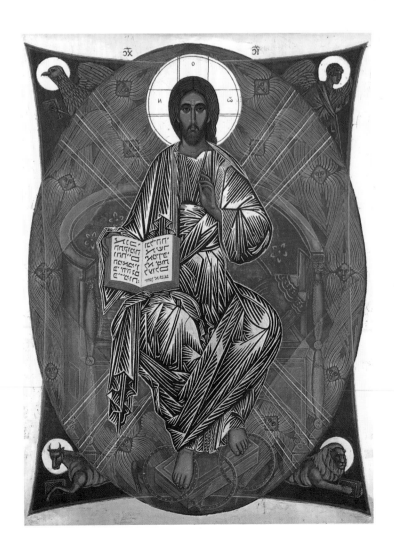

Landscape in icons – mountains and vegetation

Mountains and vegetation in icons, like the architecture, are represented as background props, and are all part of a cosmic scheme. Man's journey of ascent to the divine is symbolized by a series of metaphoric levels in the composition, which for simplicity could be summarized as: the level of darkness, the earthly level of man and the divine level, where God is represented either symbolically as a circle (see front cover) or by Christ himself.

A common feature in icons is the symbol of the dark cave, the cosmos in darkness awaiting Revelation. This is shown in icons of the Nativity, the Raising of Lazarus (see page 59), St. George and the Dragon (see below), and Mount Calvary (see page 67) where the skull of Adam can be seen in the small cave at the foot of the cross. Sometimes the cave is represented in the form of black windows or doors in the buildings.

Mountains, where God's presence was manifested, are an ancient symbol. Their outlines, and the design of the light patterns on the slopes, are represented as if inclining towards the holy saint in respect (see page 59), signifying that even created matter has been transformed by the holy presence. Trees and vegetation also acknowledge this presence by bending towards the saint, or bursting forth towards the realm of the divine in joyous praise. In this art form all elements are affected by the subject matter and give meaning to it with simplicity, spiritual harmony and unity. Nothing is left to the whim of the artist.

St George and the Dragon. Based on a Cretan school icon (circa 1500) in the Hellenic Institute of Byzantine and post-Byzantine Studies, Venice. 33.25 × 25.5cm (13⅛ × 10in). Original 82.5 × 65.5cm (32½ × 25¾in).

Transfiguration. Based on a Cretan school icon (circa 1535), attributed to the monk Theophanes Bathos. Original in the Catholicon Monastery of the Great Lavra, Mount Athos. 49.5 × 36cm (19½ × 14⅛in). Original 64 × 46cm (25¼ × 18⅛in).

The Baptism of Christ. Based on an icon by a Greek painter working at Ohrid circa 1300. Church of the Virgin Peribleptos, now in the Icon Gallery in the Church of St Clement, Ohrid, Yugoslavia. 41 × 30.7cm (16¼ × 12¼in). Original 47 × 38cm (18½ × 15in).

The Raising of Lazarus. Based on a fifteenth century Russian icon.
28 × 21.25cm (11 × 8⅜in).

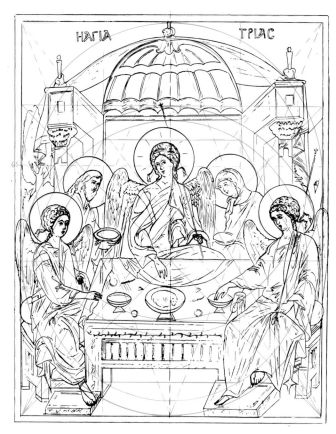

Geometric figures underlying the composition of the drawing of the icon of the Holy Trinity on page 66.

Sacred geometry and proportion: analysing the composition

In an icon with several figures, the overall composition falls naturally into geometric forms, the triangle, square and circle (corresponding to the numbers 3, 4 and 1). The ideas of Pythagoras and Plato on forms and numbers were reinterpreted in the Christian tradition, where geometric forms and numbers had symbolic meanings. Here the square represents the earth (with the four Evangelists at each corner), the triangle the Trinity, and the circle the Divine Unity. The proportions of the panel are often 4:3 (height:width) giving a diagonal of 5. The simplicity of these numerical relationships was given symbolic significance. Another symbolic proportion, the "Golden Section", can be constructed only geometrically (from a pentagon), and since it is found in nature, it has been considered since classical times as the proportion of harmony (see page 63). Christian artists have related the proportional relationships of the Golden Section to the mystery of God; hence it is called the Divine proportion (Luca Pacioli, Venice 1509).

To study the geometric forms underlining the composition, place a piece of tracing paper over a reproduction. First find the centre of the composition by drawing a vertical and horizontal axis. Every artist knows that this divides the composition into two plains to which all shapes relate in space. Now draw two diagonals across the rectangle. On the base of the rectangle draw a square across the full width. Draw a circle to fill this square. Now use the vertical axis to draw a series of circles, symmetrical triangles, a pentagon or a hexagon to fit the main shapes of the composition, to discover how they are related. The composition could also be divided horizontally into three or four bands or levels, or into the proportions of the Golden Section. (See page 63 for the geometric construction of forms referred to in this section.)

You will notice that what is applicable to the whole composition is also relevant to the separate sections and even to details. The "negative spaces", i.e. the shapes of the gaps between the figures, are also important in a composition. The early icon painters did not consciously make geometrical diagrams. They were already trained to perceive harmony, order and proportion and worked intuitively. Our purpose in analyzing this "sacred geometry" is to discover how they used forms to convey the spiritual meaning of the icon.

60

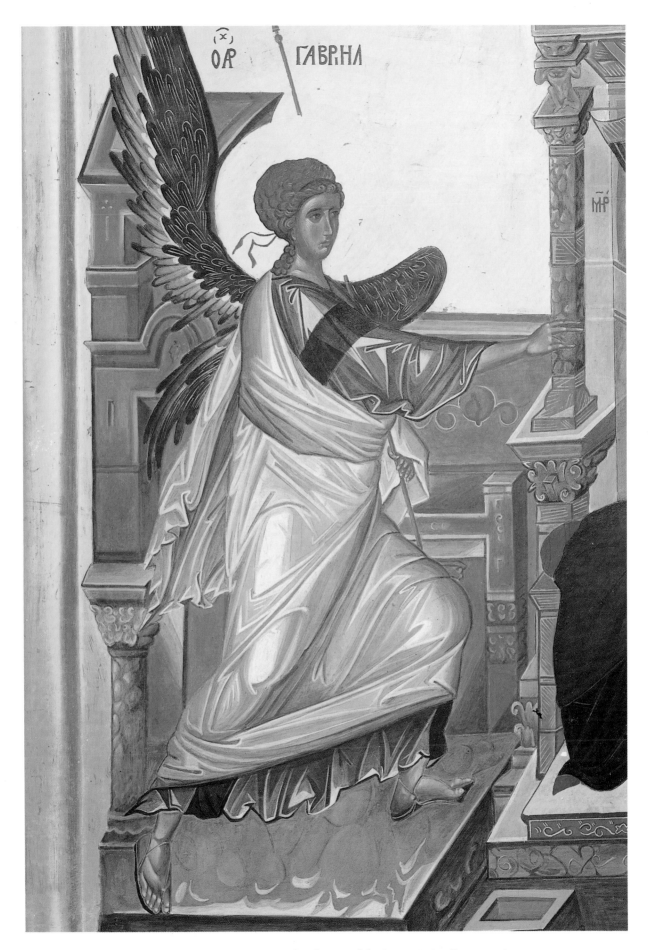

Detail of the Archangel Gabriel in the icon of the Annunciation (front cover).

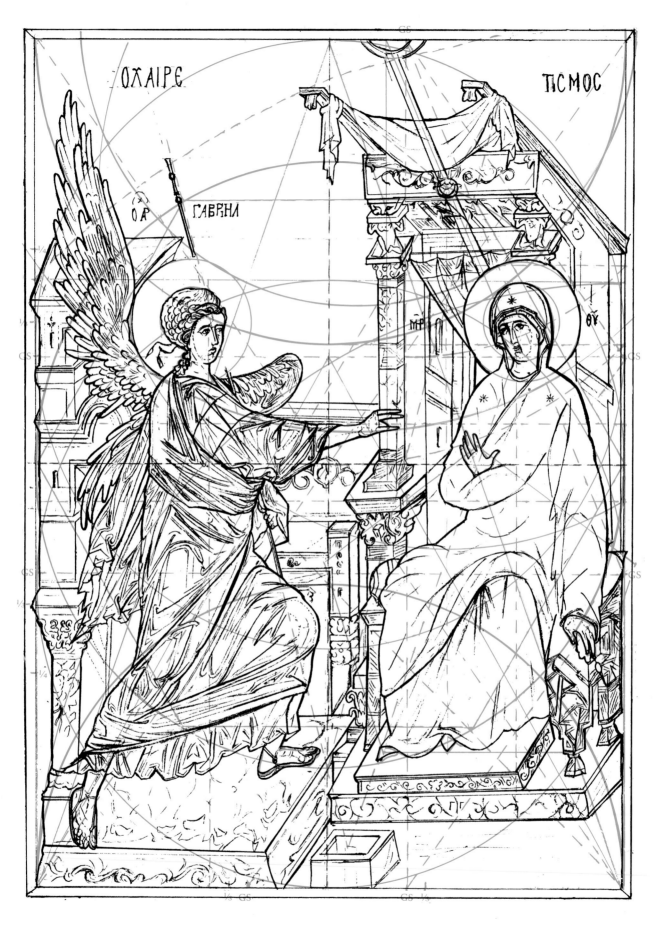

OΧΑΙΡΕ ΠΙCΜΟC

Ὁ Ἀ ΓΑΒΡΗΛ ΜΡ ΘΥ

Geometric figures underlying the composition of the drawing of the icon of the Annunciation on page 55. They include: a hexagon, pentagon, 'vesica piscis', golden proportion and root rectangle (see opposite page for the construction of these and other figures).

Geometric constructions

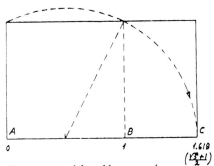

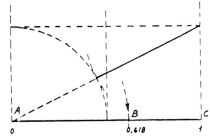

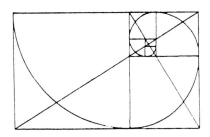

Construction of the golden rectangle from a given square.
Harmonic proportion AB:BC=AC:AB.
A 5:8 rectangle will be an approximation.

Construction of the golden proportion of a given segment. AB:BC=AC:AB.

Development of golden rectangles and spiral within a golden rectangle.

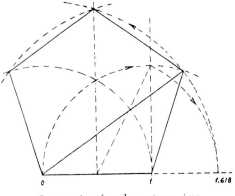

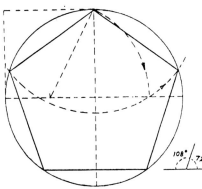

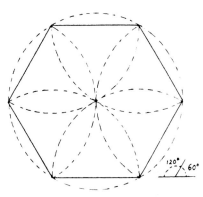

Construction of regular pentagon given length of side (compare construction of the golden rectangle).

Construction of the pentagon within a given circle.

The hexagon within a given circle.

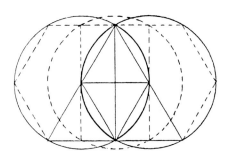

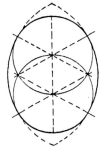

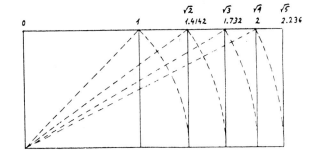

Construction of the vesica piscis (almond shape) by two intersecting circles, and its relation to the equilateral triangle, hexagon and √3 rectangle.

Constructing the oval, given its longer axis, another form of the vesica piscis or mandorla.

Development of "root" rectangles from a given square.

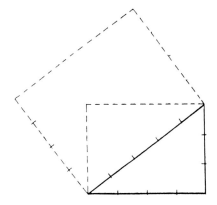

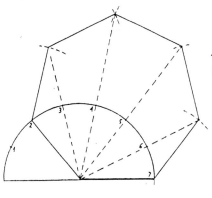

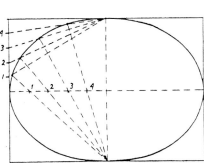

The 4:5 and 3:4 rectangles, from the 4:3:5 triangle.

Construction of a regular polygon given its side length (in this case a heptagon).

Construction of an ellipse within a given rectangle.

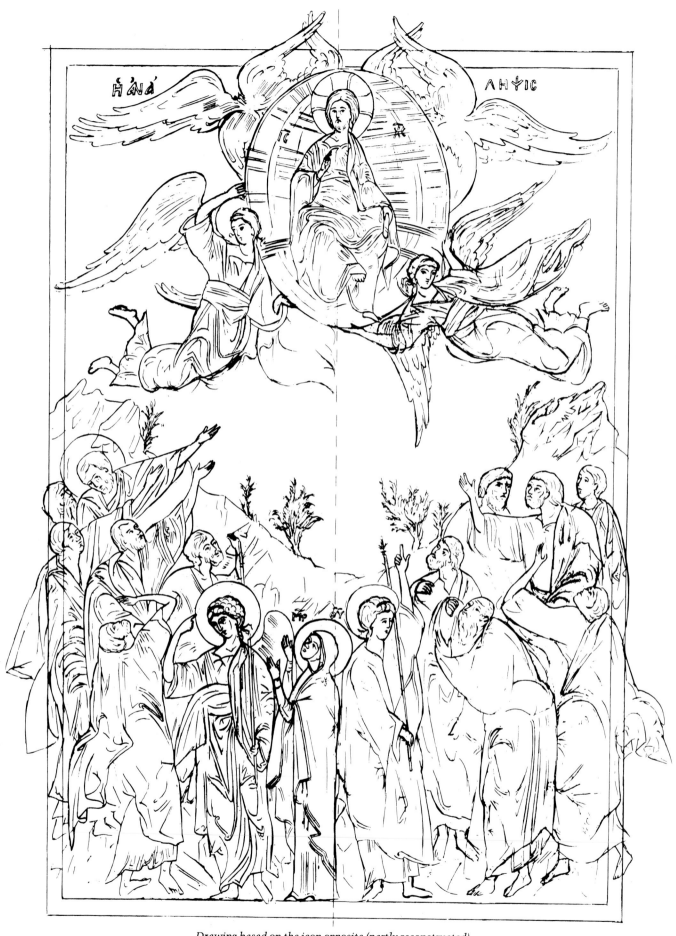

Drawing based on the icon opposite (partly reconstructed).

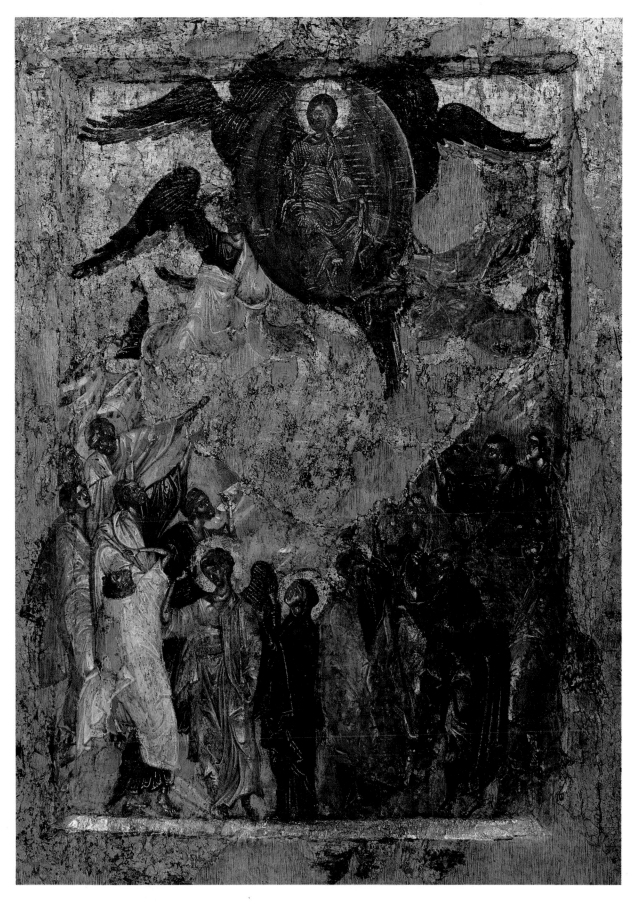

The Ascension of Christ into Heaven. Late fourteenth century Byzantine icon, possibly from Constantinople. (Similarities in style with the icon of the Ascension in Ohrid Icon Gallery, Yugoslavia). 38 × 28cm (15 × 11in). Icon at the Menil Museum, Houston, Texas, U.S.A. (Photograph courtesy of the Temple Gallery, London.)

Line drawing of the icon of The Old Testament Holy Trinity (or The Hospitality of Abraham and Sarah). Based on a late fourteenth century icon in Mount Athos. Lower part reconstructed. (This icon has certain similarities with the icon in the Benaki Museum, Athens, and with the later sixteenth century Cretan icon in the Byzantine Museum, Athens.) Original with silver plaques on the background 117 × 92cm (46 × 36¼in).

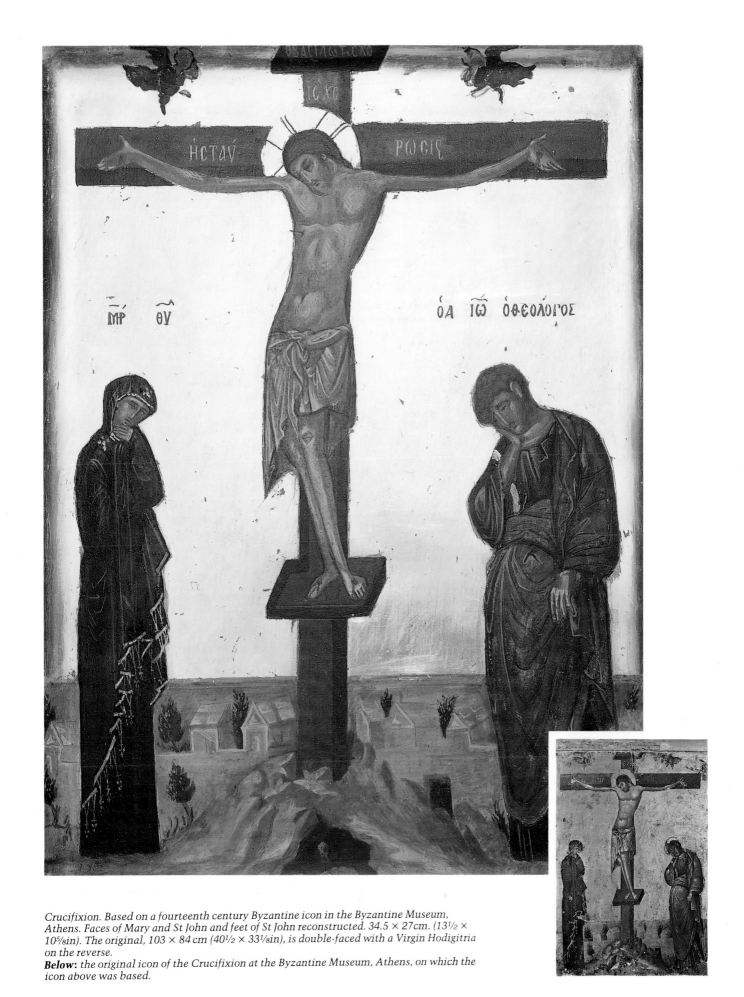

Crucifixion. Based on a fourteenth century Byzantine icon in the Byzantine Museum, Athens. Faces of Mary and St John and feet of St John reconstructed. 34.5 × 27cm. (13½ × 10⅝in). The original, 103 × 84cm (40½ × 33⅛in), is double-faced with a Virgin Hodigitria on the reverse.
Below: *the original icon of the Crucifixion at the Byzantine Museum, Athens, on which the icon above was based.*

Icons in Western churches and chapels

The move towards contemporary art forms in churches in Western Europe has been accompanied by an increasing interest in early icons. Many modern chapels and prayer rooms have incorporated copies of early icons amongst modern furnishings, paintings and stained glass, to give an interesting juxtaposition of old and new. In the Lady Chapel of a church, we often find an icon of Our Lady of Perpetual Succour (or the Virgin of the Passion) displayed on a modern shrine, (see above). Icons are also found in non-Orthodox homes as an aid to prayer.

Rites for the blessing of icons

Roman Catholic

The best occasion for blessing an icon is during the Eucharist. The icon is placed on the altar before the service begins, and this is conducted in the normal way until after the Penitential Rite (or Rite of Reconciliation). Then, before the *Gloria* is said or sung, the celebrant says or chants a Prayer of Blessing. This can take several forms: short forms for blessing an icon of Christ and of a saint are given below; or a longer form as shown opposite.

Short prayer of blessing for an icon of Christ

With arms outstretched, the celebrant says
Lord,
although your glory lies beyond our sight,
out of your great love
you have revealed yourself in the person of Christ.
May those who have crafted
this icon of your Son
show him honour by growing in his likeness,
who is Lord for ever and ever.

The people answer
Amen.

Prayer of blessing for an icon of a saint

O God
source of all grace and holiness,
look kindly on your servants
who have crafted this icon of Saint N.,
the friend and co-heir of Christ.
He/she is for us your witness to the life of the Gospel
and stands in your presence to plead for us.
Grant that we may benefit from his/her intercession.
We ask this through Christ our Lord.
Amen.

After the prayer of blessing, the celebrant places incense in the censer and incenses the icon, while an antiphon, psalm, hymn or other song suited to the mystery represented by the icon is sung.
The Eucharist then continues as usual, with the icon remaining on the altar throughout the service.

Longer form of prayer of blessing for an image of Christ

With hands outstretched, the celebrant says the prayer of blessing
Good Father,
lover of the human race,
we praise you for the great love shown us
in the sending of your Word.
Born of the Virgin,
He became our Saviour,
our firstborn brother,
like us in all things but sin.

You have given us Christ
as the perfect example of holiness:

We see him as a child in the manger,
yet acknowledge him God almighty.

We see his face
and discern the countenance of your goodness.

We hear him speak the words of life
and are filled with your wisdom.

We search the deepest reaches of his heart
and our own hearts burn with that fire of the Spirit
which he spread in order to renew the face of the earth.

We look on the Bridegroom of the Church,
streaked in his own blood,
but we revere that blood,
which washes our sins away.

The Church rejoices in the glory of his resurrection
and shares in the promise it holds.

Lord,
listen to our prayer.
As your faithful people honour this image of your Son
may they be of one mind with Christ.
May they exchange the image of the old Adam of earth
by being transformed into Christ, the new Adam from
heaven.

May Christ be the way that leads them to you,
the truth that shines in their hearts,
the life that animates their actions.

May Christ be a light to their footsteps,
a safe place of rest on their journey,
and the gate that opens to them the city of peace.
For he lives there reigning with you and the Holy Spirit,
one God for ever and ever.

The people answer
Amen.

Orthodox

It is customary for the icon to stand in the sanctuary for a symbolic forty days before the final blessing. In a special short service, the icon is anointed with the holy oil used in the consecration of altar vessels or of a church. This blessing bestows on the icon something of the person it represents, endowing the material with a spiritual quality.

The priest (P) says
Blessed is our God always, both now and for ever, and unto ages of ages.

The chantor (C) responds
Amen.

There follows the Trisagion Prayers: *O All-holy Trinity . . . Our Father . . . ending: P. For yours is the kingdom . . . C. Amen. Then the* Kyrie Eleison *is said, followed by the Prayer of Blessing*

O Lord our God, who created us after your own image and likeness; who redeems us from our former corruption of the ancient curse, through Christ who befriended all mankind, who took upon himself the form of a servant and became man; who having taken upon himself our likeness remade your saints of the "first dispensation" (the first covenant or mosaic dispensation), and through whom also we are refashioned in the image of your pure blessedness; your saints we venerate as being in your image and likeness, and we adore and glorify you as our creator. Therefore we pray you, send forth your blessing upon this icon, and with the sprinkling of this holy water (or annointing with this holy oil), bless and make holy this icon unto your glory, in honour and remembrance of your Saint . . .; and grant that this sanctification will be to all who venerate this icon of Saint . . ., and send up their prayer unto you, standing before it; through the grace, bounty and love of your only-begotten Son, with whom you are blessed together with your all-holy, good and life-creating Spirit; both now and ever, and unto ages of ages.

The priest takes the censer and with a cross-like movement incenses the icon, sprinkling it with holy water (or anointing it with oil), he then says:
Hallowed and blessed is this icon of Saint N by the grace of the Holy Spirit, through the sprinkling of holy water: in the name of the Father and of the Son and of the Holy Spirit. Amen.

Then the Troparion *and* Kontakion *of the Saint shown on the icon are sung, and all reverence and kiss the icon. The* little Apolysis *follows, including the name of the Saint.*

Note

The full Orthodox rite for the blessing of icons can be found in *The Blessing of Ikons*, translated by Mother Thekla from the Russian *Trebnik* (Book of Needs) and published by the Greek Orthodox Monastery of the Assumption, Normanby, Whitby, N. Yorks, YO22 4PS, England, in their "Library of Orthodox Thinking" series of pamphlets.

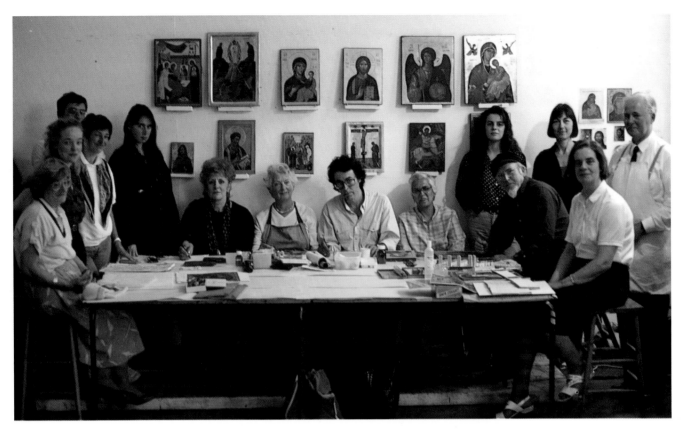

The author with some of his students whose icons are illustrated in this book. From left to right: Jean Dowling, Lola-Maria Gibbard, Protoklis-Pieris Nicola, Jan Reeves, Baboo Roberts, Patricia Hamilton, Beryl Howson, Guillem Ramos-Poquí, Ella D'Souza, Vassa Nicolau, Bonnez Le Touzel, Jacqueline Klemes, Joan Wright, Edward Johnson.

The tradition of the icon

Byzantine icon painting is governed by tradition and artistic convention. This tradition has, however, developed and changed over the centuries. Specialists are thus able to determine approximate dates, for icons are very rarely dated or signed.

Icon students often ask if it would be possible to paint a modern icon. Any attempt to modernize icons could also place them in a Western tradition. Nevertheless, an "icon" like any other form of sacred art, may be painted today by an expert for a particular purpose, place or person, or for the artist's own spiritual intention. There has been a movement this century within the Orthodox Churches (Russian, Greek and Coptic) to revive the early styles. Recreating this ancient, but still living tradition requires a deep understanding.

The student would benefit greatly however by making studies from the works of Duccio. This Sienese painter reinterpreted and transformed the Eastern tradition in an Italianate-Byzantine style. See the study of Duccio's Transfiguration (from the National Gallery, London) on page 71.

Eclectic icons are those incorporating elements from different schools or periods, such as the icon in Greek and Russian style with Hebrew text on page 56. To the purist wishing to preserve each tradition, this would seem questionable.

Under the Mannerist influence of the late Renaissance and Baroque, the style of icons gradually changed into an eclectic art form far removed from the true Byzantine tradition which is the subject of this book.

When making studies or copies of icons, it is important to realize that the purpose is not to make an antique by faking the damage caused by the ravages of time, such as seige, fire, flood, woodworm, candle smoke, handling, cracks, overpainting, varnishing, and possibly even restoration! The intention should be to restore the image to its original splendour, even if this is an impossible task.

If your model is badly damaged with missing sections, some detective work will be required to reconstruct the composition. Refer to other works of the same subject, style and period (not necessarily

painted), such as mosaics, ivories or illuminated manuscripts. This is a fascinating field of research. The models or prototypes used should always be of the highest artistic merit in order to learn as much as possible. It may be best to specialize in a certain style or school or period. When you are perfectly familiar with this style you may be able to paint freely, recreating the model from memory, but this could take many years.

Some people consider painting icons an uncreative anachronism. This could equally well be said of singing plainchant or interpreting any other such time-honoured form of art or music. An icon is said to be a mirror of divine revelation. A painter's interpretation of it is also a reflection of his spiritual attitude. A good craftsman may make a competent copy, but the true artist tries with reverence to capture the spirit of the icon.

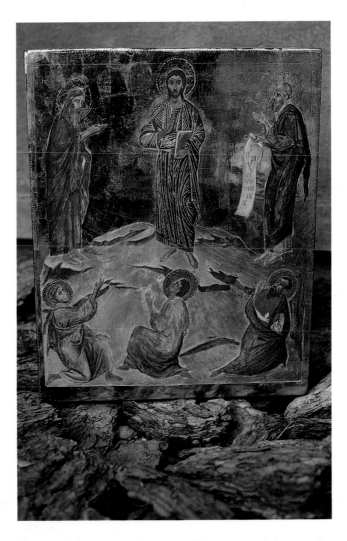

The Transfiguration. Based on a panel by Duccio, early fourteenth century, School of Siena. 29 × 25cm (11½ × 9¾in). Benedictine Monastery of Christ in the Desert, Abiquiu, New Mexico, U.S.A. Original 44.1 × 46cm (17⅜ × 18⅛in) at the National Gallery, London (see detail of the figure of Christ from the original on page 53)

Triumph of Orthodoxy. Detail (upper register) of a late fourteenth or early fifteenth century icon from Constantinople at the British Museum, London. This is an icon commemorating the Feast of the Restoration of Icons after the Iconoclasm in AD843. In the centre is the icon of the Virgin Hodigitria carried in procession. To the left stand the Regent, Theodora, and her young son, the Emperor Michael III. To the right stand Methodius, the Patriarch of Constantinople, and the supporters of the Iconophile cause. Complete icon 39 × 31cm (15⅜ × 12¼in).

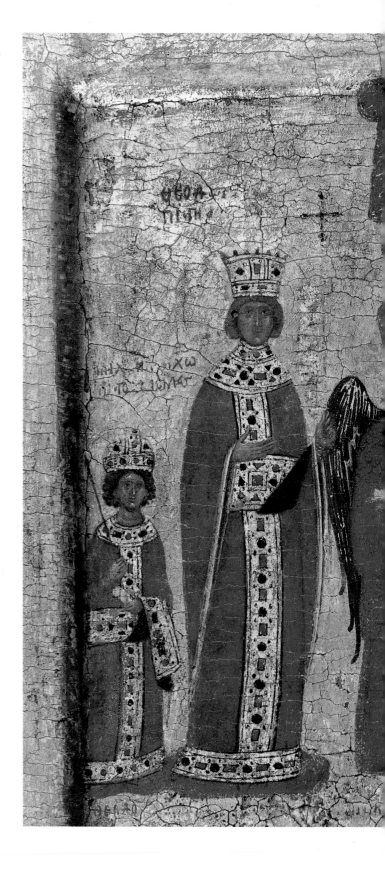

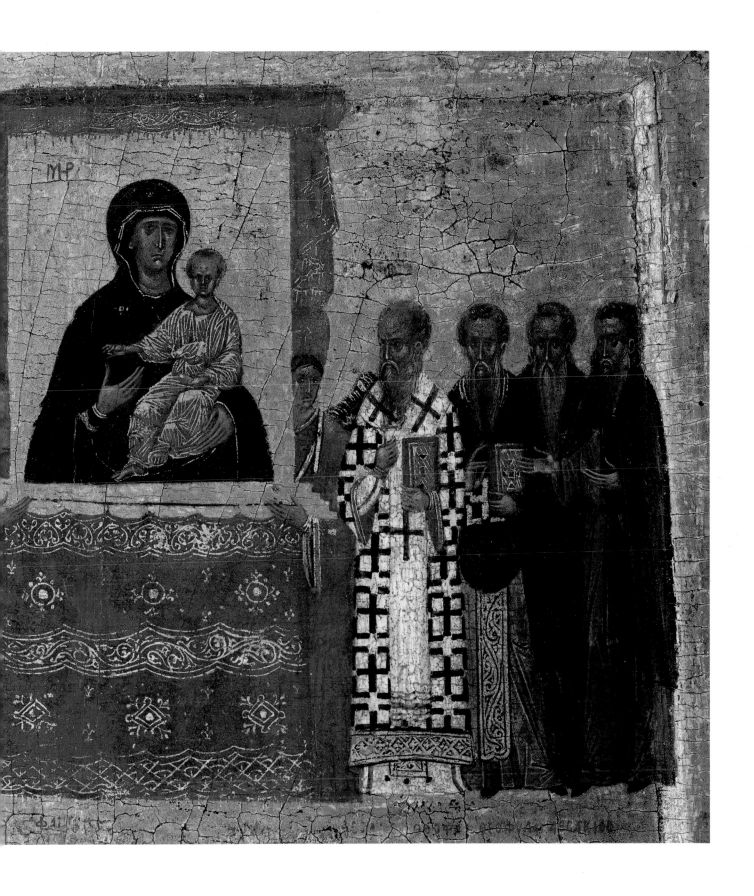

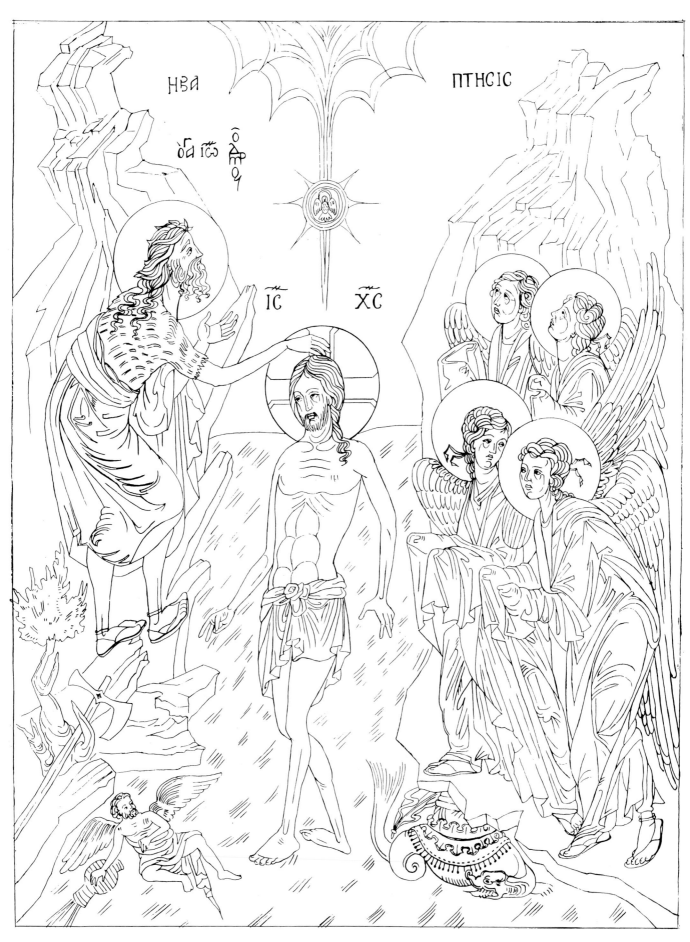

Line drawing for the icon of the Baptism of Christ on page 58.

Byzantine alphabet and inscriptions

BYZANTINE ALPHABET (letters in brackets: modern Greek).

ⲁ Ⲁλ (A), B (B), Γ, Δ (Δ), Є (E), Υ V (Υ), Z, H, θ (Θ), I, K, λ Λ, M, N, Ƶ (Ξ Ξ), O, Π Γ, P, C (Σ), T, Φ, X, Ψ, Ѡ (Ω). Usual contractions: ⲁ͞Р = ⲁР, ⲁ͞Ν = ⲁΝ, Æ = ⲁB, ⲁ͞Т = ⲁT, M͞P = MHP, Ǫ = OC, Ƥ = PI, ⲱ͞ = ѠP, Ϛ = CT

BYZANTINE INSCRIPTIONS IN THE ICONS REPRODUCED IN THIS BOOK

Recurring inscriptions. The letters which have been omitted in these abbreviations are shown in brackets.

I͞C X͞C Jesus Christ - abbreviated from: I(HCOY)C X(PICTO)C , O ѠN "The Being" (inside the halo)

M͞P Θ͞Y Mother of God - abbreviated from: MH(TH)P Θ(ЄO)Y , M͞P is a contraction of MHP, see above.

O A͞P͞X The Archangel - abbreviated from: O APX(AΓΓЄΛOC) , also written O͞Ⲁ͞Р͞

O A͞Γ The Saint - abbreviated from: O AΓ(IOC), also written O Γ͞ⲁ , or: O ⲁ Ǫ = AΓ(I)OC

PAGE

cover O XAIPЄTICMOC The Annunciation M͞P Θ͞Y Mother of God, O͞Ⲁ͞Р ΓⲀBPIHΛ Archangel Gabriel

3 M͞P Θ͞Y Mother of God, I͞C X͞C Jesus Christ O͞Ⲁ͞Р Archangel M͞ Michael - abbreviated from M(IXⲀHΛ)
O͞Ⲁ͞Р Archangel Γ͞ Gabriel: abbreviated from Γ(ⲀBPIHΛ)

7 TѠ AΓION MANΔIΛYѠN The Holy Mandylion, correct modern script: TO AΓION MANΔYΛION, I͞C X͞C Jesus Christ

17 O͞Ⲁ͞Р Archangel MIXⲁΛ Michael, abbreviation of MIXⲁ(H)Λ, also written MIXⲁ͞
O MЄΓⲀC TⲀƵIⲀPXHC The Great Taxiarch
Δ͞ X͞ Κ͞ abbreviated from X(PICTOC) Christ, Δ(IKⲀIOC) Righteous, K(PITHC) Judge.

23 O A͞Γ Saint MⲀTΘⲀIOC Matthew, written M͞ⲀͤΘ͞ⲁIǪ , see contractions.

35 H OΔHΓHTPIⲁ The Hodigitria, M͞P Θ͞Y Mother of God, I͞C X͞C Jesus Christ, O ѠN The Being (Ever-existing)

42 O ΠⲀΝTOKPⲀTⲱ͞ The Pantocrator, I͞C X͞C, O ѠN see No. 35

43 O A͞Γ Saint I͞Ѡ John - abbreviation from IѠ(ANNHC)
O Ƥ͞P͞Ǫ the Forerunner - contraction of the abbreviation of O Π(PO)ΔP(O)MOC

43 O͞Ⲁ͞Р ΓⲀBP͞ Archangel Gabriel, see no. 3.

52 O A͞Γ Saint CYMЄѠN Symeon O ΘЄOΔOXOC The Theodochos (Receiver of God), I͞C X͞C Jesus Christ

52 M͞P Θ͞Y Mother of God H KⲀTⲀΦYΓH of Katafigi, O͞Ⲁ I͞Ѡ Saint John O ΘЄOΛOΓOC the Theologian

57 O Γ͞ⲁ Ǫ Saint ΓЄOPΓHǪ George, correct modern script: ΓЄѠPΓIOC

57 H MЄTⲀMOPΦѠCIC The Transfiguration, I͞C X͞C Jesus Christ

58 H BⲀΠTHCIC The Baptism, I͞C X͞C Jesus Christ, O͞Ⲁ I͞Ѡ O Ƥ͞P͞Ǫ Saint John the Forerunner - see No. 43

64 H ⲀNⲁΛHYIC The Ascension, I͞C X͞C Jesus Christ, M͞P Θ͞Y Mother of God

66 H ⲀΓIⲁ TPIⲁC The Holy Trinity

67 O BⲀCIΛЄYC The King, H CTⲀYPѠCIC The Crucifixion, I͞C X͞C Jesus Christ
M͞P Θ͞Y Mother of God, O͞Ⲁ I͞Ѡ Saint John, O ΘЄOΛOΓOC the Theologian

Biblical readings for selected icons in this book

These texts are taken from the Jerusalem Bible

The Annunciation (front cover)
Gospel according to St Luke 1:26–38

In the sixth month the angel Gabriel was sent by God to a town in Galilee called Nazareth, to a virgin betrothed to a man named Joseph, of the House of David; and the virgin's name was Mary. He went in and said to her, 'Rejoice, so highly favoured! The Lord is with you'. She was deeply disturbed by these words and asked herself what this greeting could mean, but the angel said to her, 'Mary, do not be afraid; you have won God's favour. Listen! You are to conceive and bear a son, and you must name him Jesus. He will be great and will be called Son of the Most High. The Lord God will give him the throne of his ancestor David; he will rule over the House of Jacob for ever and his reign will have no end.' Mary said to the angel, 'But how can this come about, since I am a virgin?' 'The Holy Spirit will come upon you' the angel answered 'and the power of the Most High will cover you with its shadow. And so the child will be holy and will be called Son of God. Know this too: your kinswoman Elizabeth has, in her old age, herself conceived a son, and she whom people called barren is now in her sixth month, *for nothing is impossible to God.*' 'I am the handmaid of the Lord,' said Mary 'let what you have said be done to me.' And the angel left her.

The Mandylion (page 7)
Gospel according to St Mark 14:58

I am going to destroy this Temple made by human hands, and in three days build another, not made by human hands.

St Peter (page 16)
The text on the scroll is from the First Letter of Peter 2:11 and it translates:

"I urge you, my dear people, while you are visitors and pilgrims, to keep yourselves free from selfish passions that attack the soul."

St Matthew (page 23)
The text on the book is taken from the Gospel according to St Matthew 1:1 and it translates:

"A genealogy of Jesus Christ, son of David, son of Abraham."

The Archangel Gabriel (page 43)
The text on the scroll is taken from the First Letter of Peter 3:12 and it translates:

(The eyes of the Lord are upon the righteous and his ears are open to their prayers). "Because the face of the Lord frowns on evil men, but the eyes of the Lord are turned towards the virtuous."

St Symeon with the Christ child (page 52)
The text on the scroll is taken from the Gospel according to St Luke 2:34 and it translates:

". . . you see this child: he is destined for the fall and for the rising of many in Israel . . ."

Christ in Glory (page 56)
Revelations 4:1–8

Then, in my vision, I saw a door open in heaven and heard the same voice speaking to me, the voice like a trumpet, saying, 'Come up here: I will show you *what is to come* in the future'. With that, the Spirit possessed me and I saw a throne standing in heaven, and the *One* who was *sitting on the throne,* and the Person sitting there looked like a diamond and a ruby. There was a rainbow encircling the throne, and this looked like an emerald. Round the throne in a circle were twenty-four thrones, and on them I saw twenty-four elders sitting, dressed in white robes with golden crowns on their heads. Flashes of lightning were coming from the throne, and the sound of peals of thunder, and in front of the throne there were seven flaming lamps burning, the seven Spirits of God. Between the throne and myself was a sea that seemed to be made of glass, like crystal. *In the centre,* grouped round the throne itself, were *four animals with many eyes,* in front and behind. *The first* animal was like *a lion, the second* like *a bull, the third* animal had *a human face,* and *the fourth* animal was like a flying *eagle. Each* of the four animals had *six wings* and *had eyes all the way round* as well as inside; and day and night they never stopped singing:

'Holy, Holy, Holy
is the Lord God, the Almighty;
he was, he is and he is to come'.

The Transfiguration (page 57, also page 71)
Gospel according to St Matthew 17:1–8.

Six days later, Jesus took with him Peter and James and his brother John and led them up a high mountain where they could be alone. There in their presence he was transfigured: his face shone like the sun and his clothes became as white as the light. Suddenly Moses and Elijah appeared to them; they were talking with him. Then Peter spoke to Jesus. 'Lord,' he said 'it is wonderful for us to be here; if you wish, I will make three tents here, one for you, one for Moses and one for Elijah.' He was still speaking when suddenly a bright cloud covered them with shadow, and from the cloud there came a voice which said, 'This is my Son, the Beloved; he enjoys my favour. Listen to him.' When they heard this, the disciples fell on their faces, overcome with fear. But Jesus came up and touched them. 'Stand up,' he said 'do not be afraid.' And when they raised their eyes they saw no one but only Jesus.

The Baptism of Christ (page 58)
Gospel according to St Mark 1:9–11

It was at this time that Jesus came from Nazareth in Galilee and was baptised in the Jordan by John. No sooner had he come up out of the water than he saw the heavens torn apart and the Spirit, like a dove, descending on him. And a voice came from heaven, 'You are my Son, the Beloved; my favour rests on you'.

The Resurrection of Lazarus (page 59)
Gospel according to St John 11:38–44

Still sighing, Jesus reached the tomb: it was a cave with a stone to close the opening. Jesus said, 'Take the stone away'. Martha said to him, 'Lord, by now he will smell; this is the fourth day'. Jesus replied, 'Have I not told you that if you believe you will see the glory of God?' So they took away the stone. Then Jesus lifted up his eyes and said:

'Father, I thank you for hearing my prayer.
I knew indeed that you always hear me,
but I speak
for the sake of all these who stand round me,
so that they may believe it was you who sent me.'

When he had said this, he cried in a loud voice, 'Lazarus, here! Come out!' The dead man came out, his feet and hands bound with bands of stuff and a cloth round his face. Jesus said to them, 'Unbind him, let him go free'.

The Ascension of Christ into Heaven (page 65)
The icon shows Christ in an oval mandorla ascending to heaven surrounded by angels and seraphins. Below, the Virgin Mary, with two angels, eleven apostles and St Paul.

Gospel according to St Luke 24:50–53

Then he took them out as far as the outskirts of Bethany, and lifting up his hands he blessed them. Now as he blessed them, he withdrew from them and was carried up to heaven. They worshipped him and then went back to Jerusalem full of joy; and they were continually in the Temple praising God.

Acts of the Apostles 1:6–11

As he said this he was lifted up while they looked on, and a cloud took him from their sight. They were still staring into the sky when suddenly two men in white were standing near them and they said 'Why are you men from Galilee standing here looking into the sky? Jesus who has been taken up from you into heaven,

this same Jesus will come back in the same way as you have seen him go there.

The Old Testament Holy Trinity or the Hospitality of Abraham and Sarah [page 66]

The Old Testament, book of Genesis 18:1–15

Yahweh appeared to him at the Oak of Mamre while he was sitting by the entrance of the tent during the hottest part of the day. He looked up, and there he saw three men standing near him. As soon as he saw them he ran from the entrance of the tent to meet them, and bowed to the ground. 'My lord,' he said 'I beg you, if I find favour with you, kindly do not pass your servant by. A little water shall be brought; you shall wash your feet and lie down under the tree. Let me fetch a little bread and you shall refresh yourselves before going further. That is why you have come in your servant's direction.' They replied, 'Do as you say'.

Abraham hastened to the tent to find Sarah. 'Hurry,' he said 'knead three bushels of flour and make loaves.' Then running to the cattle Abraham took a fine and tender calf and gave it to the servant, who hurried to prepare it. Then taking cream, milk and the calf he had prepared, he laid all before them, and they ate while he remained standing near them under the tree.

'Where is your wife Sarah?' they asked him. 'She is in the tent' he replied. Then his guest said, 'I shall visit you again next year without fail, and your wife will then have a son.' Sarah was listening at the entrance of the tent behind him. Now Abraham and Sarah were old, well on in years, and Sarah had ceased to have her monthly periods. So Sarah laughed to herself, thinking, 'Now that I am past the age of child-bearing, and my husband is an old man, is

pleasure to come my way again!' But Yahweh asked Abraham, 'Why did Sarah laugh and say, "Am I really going to have child now that I am old?" Is anything too wonderful for Yahweh? At the same time next year I shall visit you again and Sarah will have a son.' 'I did not laugh' Sarah said, lying because she was afraid. But he replied, 'Oh yes, you did laugh'.

Crucifixion [page 67]

Gospel according to St John 19:17–20 and 19:25–27

They then took charge of Jesus, and carrying his own cross he went out of the city to the place of the skull or, as it was called in Hebrew, Golgotha, where they crucified him with two others, one on either side with Jesus in the middle. Pilate wrote out a notice and had it fixed to the cross; it ran: 'Jesus the Nazarene, King of the Jews'. . . .

Near the cross of Jesus stood his mother and his mother's sister, Mary the wife of Clopas, and Mary of Magdala. Seeing his mother and the disciple he loved standing near her, Jesus said to his mother, 'Woman, this is your son'. Then to the disciple he said, 'This is your mother'. And from that moment the disciple made a place for her in his home.

The Last Supper [page 77]

Gospel according to St Matthew 26:20–23

When evening came he was at table with the twelve disciples. And while they were eating he said, 'I tell you solemnly, one of you is about to betray me'. They were greatly distressed and started asking him in turn, 'Not I, Lord, surely?' He answered, 'Someone who has dipped his hand into the dish with me, will betray me.'

The Last Supper. Based on one of the illuminations in a Gospel book (thirteenth century) in the Monastery of Iveron, Mount Athos. Partly reconstructed, with an added inscription which translates: "The Mystical Supper".

Selected bibliography

*Books marked with a * contain good colour reproductions of icons.*

Selected reading

THE BRITISH LIBRARY. *The Christian Orient.* (Exhibition Catalogue). London, 1978.

OUSPENSKY, Leonid. LOSSKY, Vladimir. *The Meaning of Icons.* Saint Vladimir's Seminary Press, New York, 1982.*

TALBOT RICE, David. *Byzantine Art.* Penguin Books, Harmondsworth, Middlesex, 1968.

WEITZMANN, Kurt. *The Icon.* Chatto & Windus, London, 1978.

WEITZMANN, Kurt, et al. *Icons from South Eastern Europe and Sinai.* Thames and Hudson, London, 1968.*

Technical books

BORRADAILE, Viola and Rosamund. *Practical Tempera Painting, a Student's 'Cennini'.* The Dolphin Press, Brighton, 1949.

HETHERINGTON, Paul. *The 'Painter's Manual' of Dionysius of Fourna.* The Sagittarius Press, London, 1974.

KNEE, Karyl M. *The Dynamic Symmetry Proportional System.* Oakwood Publications, CA, 1988.

KONTOGLO, Fotio. *The Expression of Orthodox Iconography* (text in Greek in two volumes). Papadimitriou, Athens, 1979.

MACTAGGART, Peter and Ann. *Practical Gilding .* Mac & Me Ltd., Herts, England, 1985.

THE NATIONAL GALLERY. *Art in the Making, Italian Painting before 1400.* (1990 Exhibition Catalogue, also video), London, 1989.

HEBBLEWHITE, Ian. *Artist's materials.* Phaidon, London, 1986.

SENDLER, S.J. Egon. *The Icon, Image of the Invisible, Elements of Theology, Aesthetics and Technique* (trans. Steven Bigham). Oakwood Publications, CA, 1988.

STUART, John. *Ikons.* Faber and Faber, London, 1975.

THOMPSON Jr., Daniel V. *The Practice of Tempera Painting, Materials and Methods.* Dover Publications, New York, 1962.

THOMPSON Jr., Daniel V. *The Materials and Techniques of Medieval Painting.* Dover Publications, New York, 1956.

THOMPSON Jr., Daniel V. *The Craftsman's Handbook "Il libro dell 'Arte" Cennino d'Andrea Cennini* (trans.). Dover Publications, New York, 1960.

Specialized books

ACHEIMASTOU-POTAMIANOU, Myrtali (Editor). *From Byzantium to El Greco, Greek Frescoes and Icons.* Royal Academy of Arts (Exhibition Catalogue), London, 1980.*

ALPATOV, M.V. *Early Russian Icon Painting.* (Trans. N. Johnstone), Moscowiskusstuo, 1974.*

BABIC, Gordana, *Icons,* Bracken Books, London, 1988.

BALTOYANNI, Chrysanthi. *Icons, the D. Ekonomopoulos Collection.* Dr. D.A. Delis S.A. (Publisher), Athens, 1986.*

BANK, Alice. *Byzantine Art in the Collections of Soviet Museums.* Aurora Art Publishers, Leningrad, 1977, 1985.*

CHRISTOPOULUS, George A. BASTIAS, John C. (Publishers The Patriarchal Institute for Patristic Studies). *The Treasures of Mount Athos* (in several volumes), Ekdotike Athena S.A., Athens, 1975.*

CORMACK, Robin. *Writing in Gold.* George Philip, London, 1985.

DAMASCUS, St. John of. *On the Divine Images* (trans. D. Anderson) Saint Vladimir's Seminary Press, New York, 1987.

DIEHL, Charles. *Manuel d'art Byzantine* (two volumes), Paris 1925.

GRABAR, André. *Les revêtements en or et en argent des icones Byzantines du moyen age.* Institut Hellenique, Venice, 1975.

LAZAREV, Victor. *Storia della pittura Bizantina.* Guilio Einaudi Editore, Torino, 1967.

LOVERANCE, Rowena. *Byzantium.* British Museum Publications, London, 1988.

MILLET, Gabriel. *Recherches sur l'iconographie de l'Evangile aux XIV, XVe et XVIe Siècles* (in French), Fontemoing et Cie, Editeurs, Paris, 1916.

OLYMPIAS, nun, *Deisis, selected religious paintings* (Modern Greek icons by a nun who decorated the walls of her convent), H.C. Convent of the Annunciation, M.B., Patmos, Athens, 1989.

PAPAGEORGIOU, A. *Icons of Cyprus.* Nagel, 1969*

PAPAIOANNOU, Kostas. *Byzantine and Russian Painting.* Heros Books, London, 1968.

PASKALEVA, Kostadinka. *Bulgarian Icons through the Centuries.* Svyat Publishers, Sofia, 1987.*

SALTYKOV, A. *The Andrei Rubliov Museum of Early Russian Art.* Andronikou Monastery, Moscow, 1981.*

SHERRARD, Philip, et al. *Byzantium.* Time-Life International, B.V., 1967.

STUDITE, St. Theodore the. *On Holy Icons* (trans. K. Roth). Saint Vladimir's Seminary Press, New York, 1981.

TAYLOR, John. *Icon Painting.* Mayflower Books, New York (The Phaidon Press), 1979.*

WEITZMANN, Kurt, et al. *The Icon.* Evans Brothers, London, 1982.*

WHITE, John. *Duccio, Tuscan Art and Medieval Workshops.* Thames and Hudson, London, 1979.

Other reference books

ATTWATER, Donald. *The Penguin Dictionary of Saints.* Penguin Books, 1973.

BARASCH, Moshe. *Giotto and the language of gesture.* Cambridge University Press, 1987.

COOPER, J.C. *An Illustrated Encyclopedia of Traditional Symbols,* Thames and Hudson, London, 1978

DOCZI, György. *The Power of Limits. Proportional Harmonies in Nature, Art and Architecture.* Shambhala Pub. Inc., USA, 1981.

DU BOURGET, S.J., Pierre. *Early Christian Art.* Weidenfeld & Nicholson, London, 1972

ECCO, Umberto. *Art and Beauty in the Middle Ages.* Yale University Press, New Haven and London, 1986.

HOFSTADTER, Albert and KUHNS, Richard (Editors). *Philosophies of Art and Beauty – Selected Readings in Aesthetics from Plato to Heidegger.* The University of Chicago Press, Chicago, 1964.

LAWLOR, Robert. *Sacred Geometry, Philosophy and Practice.* Thames and Hudson, London, 1982.

NICHOLS, O.P., Aidan. *The Art of God Incarnate, Theology and Image in Christian Tradition.* Darton, Longman and Todd, London, 1980.

SCHILLER, Gertrud. *Iconography of Christian Art* (in three volumes). Lund Humphries, London, 1972.

TEMPLE, Richard. *Icons and the Origins of Christian Mysticism.* Element Books, Shaftesbury, 1990.

VAPORIS, N.M. (Editor), *An Orthodox Prayer Book.* Holy Cross Orthodox Press, Brooklyn, Mass., 1977.

Magazines

ST. JOHN OF DAMASCUS ASSOCIATION of Orthodox Iconographers, Iconologists and Architects. *The Sacred Art Journal.* Published quarterly. c/o Route 711 North, PO Box 638, Ligonier, PA 15658-0638, USA.

Index

The illustrations of the icons in this book are shown in italics

If readers have difficulty obtaining any of the materials or equipment mentioned in this book, please write for further information to the publishers.